COLOURED PENCILS FOR ALL

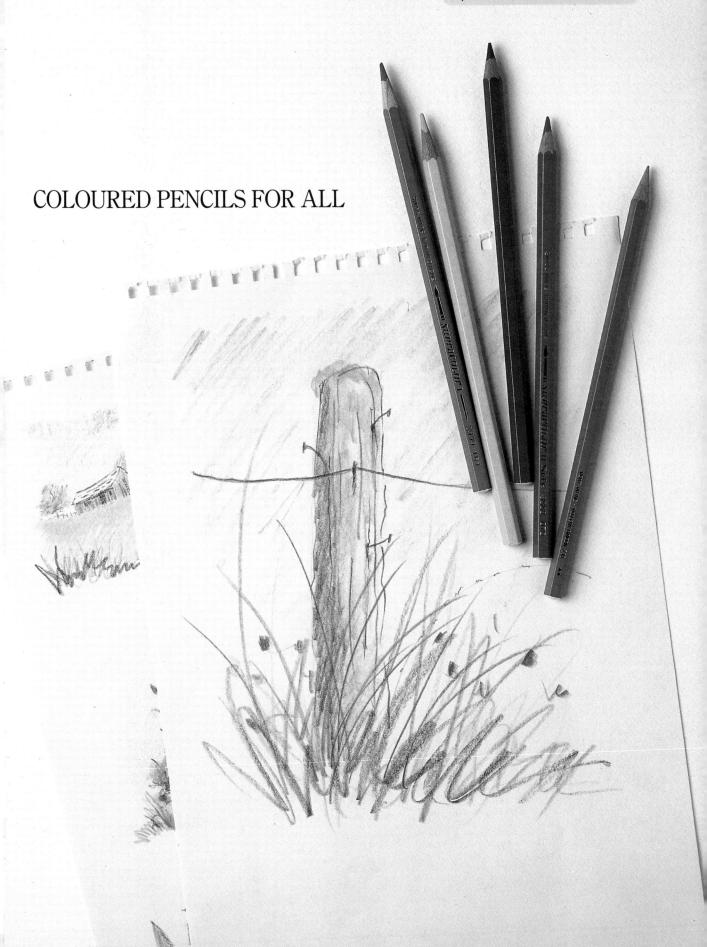

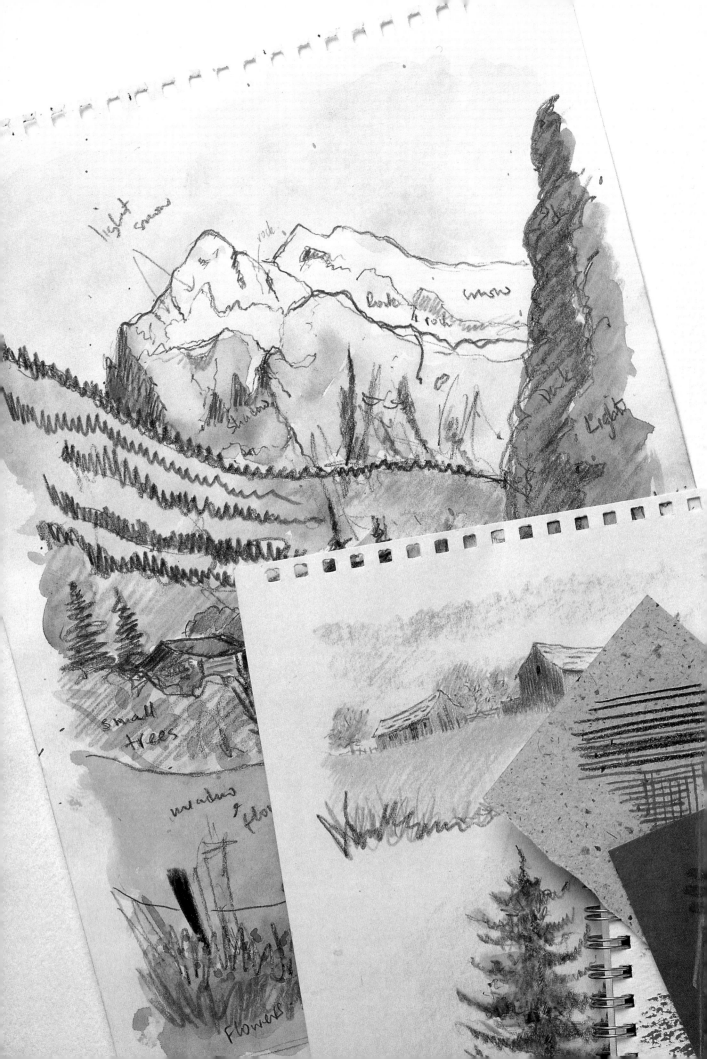

COLOURED PENCILS FOR ALL

A Comprehensive Guide To Drawing In Colour

MICHAEL WARR

David & Charles

FOR MURIEL

A DAVID & CHARLES BOOK

First published in the UK in 1996

ISBN 0 7153 0350 3

Typeset by Ace Filmsetting Ltd, Frome, Somerset
and printed in Italy by New Interlitho SpA
for David & Charles
Brunel House Newton Abbot Devon

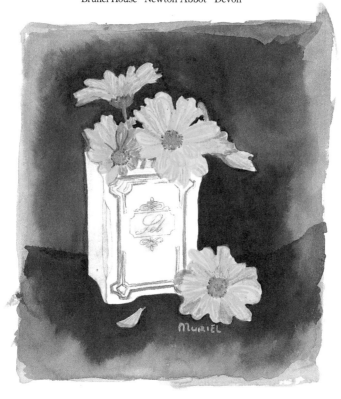

CONTENTS

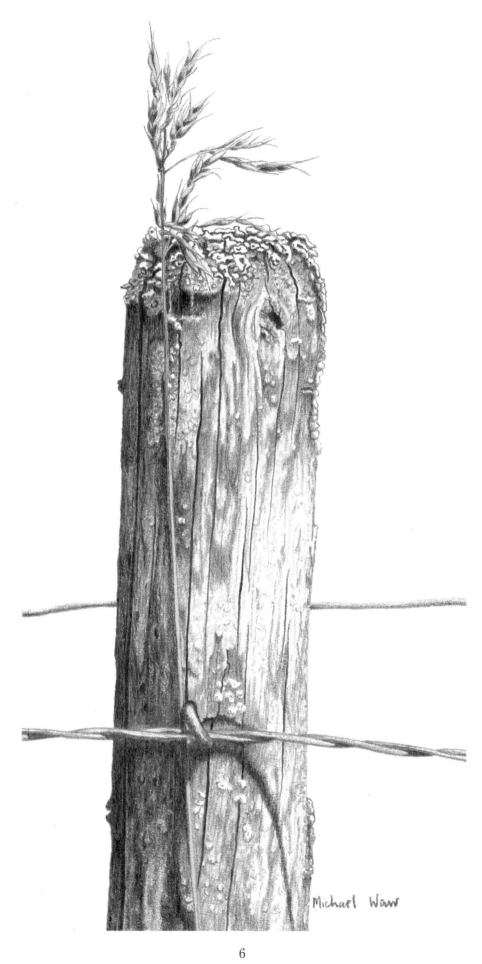

Michael Warr

INTRODUCTION

THE PENCIL IS known all over the world; it is used to scribble telephone messages, complete crossword puzzles, write shopping lists or note restaurant menu orders. Its uses seem endless and it is accessible to all! Most people do not recollect being taught how to use a pencil; it appears to be a natural ability, and it is a pity that pencil skills are not developed in a creative way by the majority, through the rewarding activity of drawing. A pencil in the right hands becomes a tool capable of producing images that retain an everlasting beauty.

In the long history of the visual arts graphite pencils are relative newcomers on the scene. The first graphite pencil was produced in 1662, some little time after pure graphite was discovered at Borrowdale in the English Lake District. The misleading description 'lead' pencil resulted because initially pure graphite was mistaken for lead. The term 'lead' is also used to describe the core of coloured pencils, which were developed much later.

An early type of coloured pencil was used by nineteenth-century architects. A brass tube formed the pencil body and held white, black or red chalk mixed with wax. But the coloured pencil as we know it today is a twentieth-century innovation. Serious development was started in the 1920s by Caran d'Ache of Switzerland. The Spanish artist Pablo Picasso (1881–1973) was using their pencils in the 1930s, and the introduction of new technology between 1950 and 1965 helped to establish the coloured pencil as a serious contender in the field of 'fine art' media. In the late 1960s the British artist David Hockney (born 1937) used coloured pencils extensively, producing drawings with a high degree of finish.

In order to cover the whole range of available materials, this book includes water-soluble pencils and crayons, pastels, wax oil crayons that can be diluted with turpentine, and water-soluble graphite pencils, all of which can be used independently or combined in one piece of work. The particular characteristics and qualities of each are outlined, and the techniques possible with each are described and illustrated, together with finished works showing how these techniques can be put into practice. Step-by-step demonstrations provide detailed guides to building up a drawing, from the first marks on paper to the finished work, in each of the different media. The chosen subjects are not too difficult and with a certain amount of practice it should be possible for you to achieve reasonable results fairly quickly.

Alpine Post

Pablo coloured pencil on illustration board

This simple fence-post in company with a single stem of grass is a ready-made subject for careful coloured-pencil work. The post and grass provide vertical shapes, while the fence wires are horizontal, creating a balanced composition. The colour contrast between the two subjects – the post and the grass – is also important.

Straightforward coloured-pencil techniques are employed here: light hatching for the woodgrain, and gentle shading in light and dark tones to give a feeling of roundness to the post and grass stem. The latter is completed first and the darker tones of the post are built around it. Finally, the fence wires are added.

DRAWING EQUIPMENT

FROM BEING a simple tool used by children, the coloured pencil in all its forms – artists' pencils, water-soluble pencils and crayons, wax crayons, and soft and oil pastels – has developed in recent years into an accepted additional medium in the world of fine art. This development has been helped by the fact that many manufacturers now produce them from good quality, lightfast pigments, which greatly enhances their appeal to professional artists and illustrators. They have the added convenience of being very easy to use and to transport on location.

The joy of coloured pencils lies in the fact that they are easy to control, at the same time offering great variety and flexibility in the range of techniques that can be employed. They can be used for all forms of drawing, with the added bonus of colour, and water-soluble pencils can be converted into washes and used like watercolour paint. Pastels can be used to draw with line, or to build up blocks of colour in a painterly way. It is also easy to mix the different media in one drawing, and to work with line and wash, or wash and pastel, for example.

COLOURED PENCILS

Most types of coloured pencils are available in three grades – school, student and artists' quality – and results will vary depending on the quality used. If you wish to begin by 'dabbling' with coloured pencils, then school or student qualities will suffice, but if you want to do serious work you should choose artists' pencils. The quality and quantity of colour pigment in a pencil determines the performance of each grade, and the price, of course! When you have decided on your approach to coloured pencil work, and should it be more serious, it is advisable to purchase the best quality that you can afford. There are differing diameter 'leads' available and choice is determined by the type of finished work required *ie* fine graphic, broad and loose, detailed or sketchy.

Like watercolour, coloured pencils have a transparent quality, allowing colours to be mixed by laying one over another – yellow over blue, for example, will create green. But unlike watercolour, there is more scope for error because coloured pencils are more forgiving. Another advantage that coloured pencils have over watercolour is that they are extremely easy to manipulate compared to a soft sable brush.

One aspect of coloured pencils that can cause alarm to the unsuspecting is a condition known as 'wax bloom'. This results from layers of colour being applied with pressure. It first appears on the surface of the drawing in the form of fogging or fading, and is caused by the wax content of the pencils rising to the surface. However, the resulting condition is not serious, and can be prevented by spraying the finished drawing with fixative. If wax bloom appears on an unfixed drawing after a week or two, light rubbing on the surface with a soft cloth will remove excess wax, although this should be done with care in order not to smudge the drawing.

The final visual impact of coloured pencils often relies on exploiting their transparency in the over-laying of colours. With at least 120 colours to use, there is plenty of scope for creating a wide range of hues and tones by overlaying and blending.

ARTISTS' TIP

Never dip water-soluble pencils directly into water because they do not absorb water in the way that brushes do, and constant immersion will damage the wooden casing.

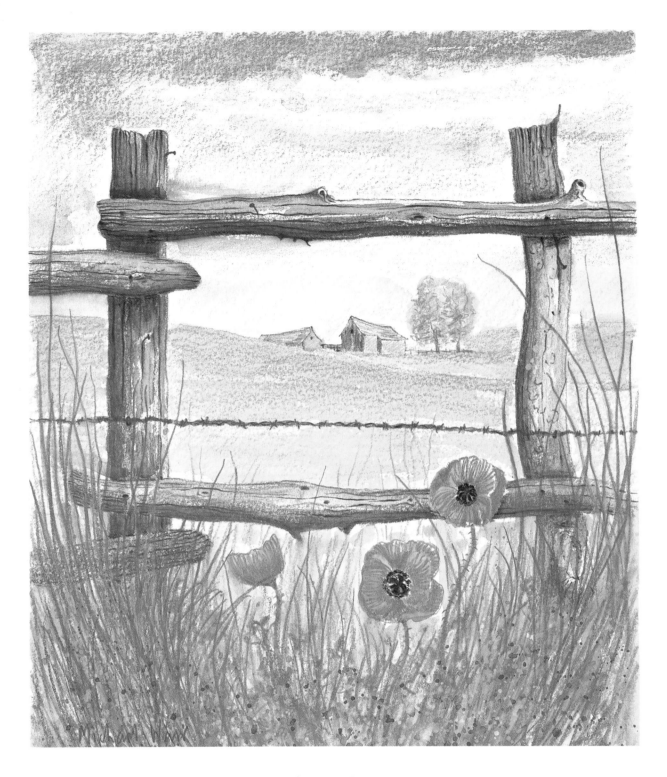

Distant Barns

Water-soluble pencil on 300gsm (140lb) Bockingford paper

An unusual view of some farm buildings, the fence providing a frame and hence creating a picture within a picture, and the bright red poppies in the immediate foreground adding a splash of colour; it provides an ideal subject for water-soluble coloured pencils. Dry colour is applied to a dry surface, the whole drawing being completed before any water is added. Water is applied to bring the drawing to life by intensifying the colours and softening the rather rigid composition, but without blending areas of colour or diluting the details. It is not necessary to flood the drawing with water to achieve this effect. Simply add enough to dilute the pigment and move it around a little.

WATER-SOLUBLE COLOURED PENCILS

Coloured pencils have been developed in a water-soluble form, offering the possibility of combining drawing and painting techniques within one medium. They are also good for building confidence because they are much easier to control than traditional methods of painting. They can provide the artist with a version of watercolour painting without the fuss and paraphernalia that watercolour requires, and they can provide a stepping-stone for those who feel that watercolour painting is too exacting for them.

As with dry coloured pencils, water-soluble pencils are available in different grades, but Caran d'Ache produce two excellent versions, both containing artists' quality pigments – a must if good results are to be obtained when the pencils are diluted with water; some pencils contain meagre amounts of poor quality pigment, causing the final work to look 'washed out'. The two versions are described as 'fine' and 'soft'; one contains harder, finer lead that is suitable for producing detail, while the softer version is better suited to free-flowing wash techniques. The two versions are compatible, and combinations of fine and soft are capable of producing a wide range of effects.

Water-soluble pencils can also be used dry, and the 'fine' version is particularly good for detailed graphic work. However, their water-soluble quality should definitely be exploited.

WATER-SOLUBLE CRAYONS

After the development of the water-soluble pencil came the very soft water-soluble crayon. In fact it is so soft that it resembles a stick of solid watercolour paint, and is a joy to use. Caran d'Ache have introduced Neocolor II crayons, and these are compatible with their pencils. It is the versatility of this medium that makes it so very interesting and exciting to use.

You can use the crayons dry, which allows you to build up the colours in layers and to experiment with sgraffito techniques (scraping off layers in order to expose the underlying colour), or you can use them in the same way as a conventional drawing instrument. However, as with water-soluble pencils, it is far greater fun to explore their water-soluble potential. In addition, pure watercolour techniques are possible by creating a palette of colours on paper using the crayons, diluting them with water and applying them with a sable brush in the conventional manner. You can draw fine lines with them by creating 'facets' at the point of the crayon, or produce wide, sweeping areas of colour with the side of the crayon, which you can then turn into a wash if appropriate. There are over eighty colours available in the range, and they can be bought in sets or singly, which is a distinct advantage if you want to experiment with the medium.

WAX OIL CRAYONS

Similar in appearance to Neocolor II water-soluble crayons, Caran d'Ache wax oil crayons are soluble in turpentine. When diluted in this way they can be used like thin, sketchy oil paint. Anyone already painting in oils may find them extremely useful for oil sketching and for studies prior to producing finished oil paintings.

Wax crayons can also be used dry, and are good for sgraffito techniques, melted-wax methods and traditional drawing. Because they are oil based, Neocolor I crayons can be used as a very effective resist in conjunction with water-based pencils or crayons (see page 50). At least thirty colours are available, and they can be bought singly or in sets.

PASTELS

Pastels are available in various forms, but the type included here are oil pastels, which contain a small amount of wax, because they relate to colour pencil techniques rather than pastel 'painting' methods.

Neopastels, manufactured by Caran d'Ache, have a slight wax content and are simpler to use than soft pastel. They do not create dust, so do not need fixing, and they are clean to use and store. Many different techniques can be tried with them, including drawing with line, blocking in solid areas of colour, scumbling layers of broken colour one over another, and mixed-media work; also the wide range of surfaces on which they can be used – including coloured and textured papers, and oil sketching paper – extends their application beyond that of traditional pastel. Ninety-six colours are available, and they can be bought singly or in sets.

GRAPHITE PENCILS

Although this book is concerned with coloured pencil techniques, graphite pencils are worth a mention because they are often used in conjunction with coloured pencil work. The softer grades are better suited to the techniques usually used in predominantly coloured works. For example, they are useful for rendering dark tones over which colour can be applied, thus enriching certain areas of a drawing by providing soft, dark colour that cannot be achieved with coloured pencil alone.

Water-soluble graphite pencils are also available, and work very well with coloured pencil techniques. There are many ways of combining coloured and graphite pencils and time spent experimenting with them is time well spent. Caran d'Ache Technalo water-soluble pencils dilute really well with water and are obtainable in grades HB, B and 3B.

Marks made with coloured pencils

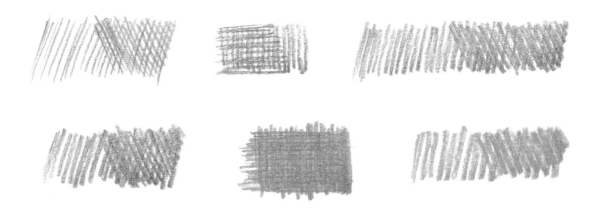

△ *Student-quality pencils (top row) produce slightly harder lines than artists' quality pencils (bottom row).*

△ *Colours can be mixed by hatching one colour over another. Blue is hatched over yellow to create green; blue over red to produce violet.*

△ *Supracolor Fine (hard) water-soluble pencils (left) and Supracolor Soft water-soluble pencils (right). Note how the softer grade dilutes more when water is added.*

◁ *Supracolor Soft pencil colours mixed with water, yellow and blue producing green.*

Marks made with coloured pencils

△ *Water-soluble crayons in their dry and wet forms. See how the colours intensify when water is added. Soft water-soluble crayons (right) mix very easily, blue and yellow producing green.*

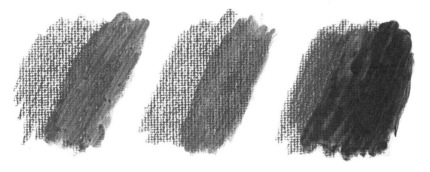

△ *Turpentine-soluble oil crayons in their dry and dilute forms. Like water-soluble crayons, they are very soft and mix with ease.*

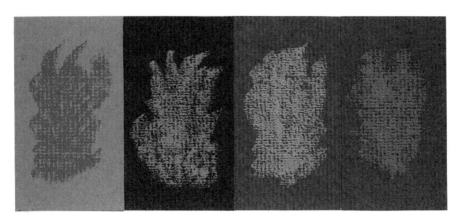

△ *Neopastel marks produced on different coloured papers. Pastel is opaque and will work well on white or any coloured surface.*

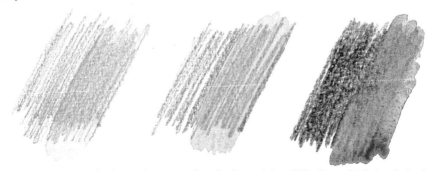

△ *Water-soluble graphite pencils in various grades. Left to right: HB, B and 3B in their dry and wet forms. The 3B dilutes more easily, the drawn lines virtually disappearing.*

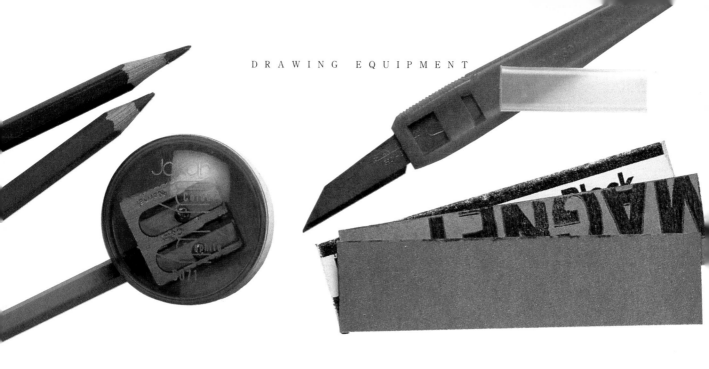

ANCILLARY EQUIPMENT

DRAWING BOARDS

A drawing board is very useful when working with coloured pencils. Boards are available in a number of sizes and are usually obtainable from your local art supplies shop or office equipment store. An alternative is to make your own. Blockboard, chipboard or medium density fibreboard are satisfactory materials to use as drawing boards, and off-cuts are normally available at your nearest DIY store. Your choice of size will obviously depend on the scale of the work that you are intending to produce.

In any event, it is of great importance when drawing to be careful about the underlying surface that is acting as a support. If paper is being used to draw on, it is a good idea to cover the drawing board with cardboard or soft plastic material because drawing requires pressure to be applied. If adequate precautions are not taken, it is possible that any unevenness on the surface underneath the paper may produce texture or patterns that are not required. Cardboard or a similar material with some 'give' under the working surface will prevent the pencil digging into the paper and cutting it, which can happen if you choose to work directly on top of a very hard support.

An independent means of support, such as a drawing board, will enable you to draw with the work surface at an angle, if this is comfortable. Normally when drawing it is not advisable to work on the flat; it is easier to see the work and to be in control somewhere around 15°. A thick book or some such similar item will suffice as a prop for the drawing board, if you do not have the luxury of a swivel top surface.

SHARPENERS

The correct way to sharpen a pencil has always provoked heated discussion among artists. In short, there is no 'correct' way; it is down to personal choice, often dictated by individual styles of working. Hand-cranked sharpeners are quite good. Being robust in construction, they normally have a long lifespan and can be clamped to any suitable surface. Hand-cranked office sharpeners usually have an expanding template, which enables them to accommodate pencils of different thicknesses. This is especially useful for coloured pencils, which tend to be thicker than the average graphite pencil. Small pocket sharpeners are suitable if they have provision for both graphite and coloured pencils.

Craft knives or specially designed blades will give you more control than a sharpener, because you can hand-sharpen the pencil. Sometimes it is desirable to expose a longer length of lead, for instance when you want to use the side of the lead to block in large areas or create a certain effect. Blades can also be used for removing unwanted colour in a drawing.

SANDPAPER BLOCKS AND FILES

If a very sharp, fine point is required for intricate details, you can hone the point on a sandpaper block. These are usually produced in pad form,

each leaf being torn off as it becomes used up. Coloured pencils cause sandpaper to clog quickly, however, and so a nail file or fine industrial file is far more economical. The latter can be cleaned from time to time with a nailbrush or old toothbrush. Remember that there is no need to waste pencil shavings; they can be diluted with water and introduced into some future work!

PENCIL EXTENDERS
Pencil extenders are a useful accessory, because a pencil soon wears down with constant use and it is impossible to draw when it becomes very short. There is loss of control, and the drawn line can no longer be seen. A pencil extender will make a short pencil easier to manipulate and will allow you to use it down to the stub so there is very little wastage.

TORTILLONS
Tortillons are rolled, compressed paper stumps, and are used mainly to blend and soften colours. They are available in various lengths and thicknesses, and are sharp at one or both ends. They pick up and often retain colour, but the colour can be removed by rubbing the tortillon on a sandpaper block. This will also ensure that a good point is retained. The pointed end of a tortillon is excellent for removing colour in order to create highlights.

ERASERS
Erasers are not as effective at removing coloured lead as they are when used to eliminate graphite

pencil marks. If the areas of coloured pencil work that you wish to remove are not too heavy or intense, plastic erasers will be reasonably successful. However, scalpel or craft knife blades, used to scrape colour carefully off the paper, will normally remove colour more efficiently. Erasers can be used to blend and soften colour or to remove some colour where a highlight is required.

FIXATIVE
Caran d'Ache produce a spray fixative to protect coloured pencil, crayon and pastel work. It will not turn colours yellow, but it can intensify them, although this may be an advantage as it can add sparkle and life to the work in the same way that a coat of varnish can lift the colours in an oil painting. Spraying will also eliminate 'wax bloom' (see page 8). It is normally recommended that spray fixative is used in a well ventilated room.

LIGHTING
If you are working in artificial light, you should consider the type of lighting available. The average lightbulb will give off a warm, yellow light that can make the colours in a coloured pencil drawing seem much warmer than they really are. Seen in the cold light of day, the same colours will appear pale and washed out. To overcome this, 'daylight' bulbs or tubes are recommended. These are designed to provide a cooler, more natural light and will render the colours in a drawing more accurately. Obviously daylight – and in particular, the north light – is really the best.

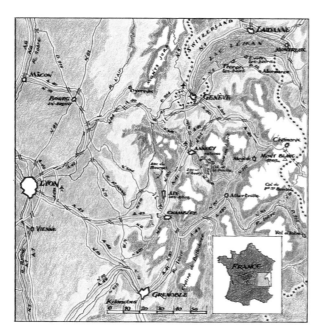

Map of Haute Savoie

ALEC WILCOX

Coloured pencil on cartridge paper

This map of the French Alps, produced for Living France *magazine, illustrates the use of coloured pencils for graphic art. Different colours are applied across a relatively small area to denote the wide range of altitudes in the region, from Lyons at 169m on the left to Mont Blanc at 4,807m on the right. The white areas, which represent the highest altitudes, are white paper. Black ink is used for the lettering and small symbols.*

Bulkington Fields Farm

Water-soluble graphite pencil on watercolour paper

This drawing, made with water-soluble graphite pencil, was produced for a client requiring a large watercolour painting of his home. A rather unusual composition was sought: instead of one aspect of the house, the client required three. It was necessary, therefore, to prepare a rough visual before embarking on the painting.

After making the drawing, water was added to soften and blend the foliage areas, linking the three views of the house together into a unified composition.

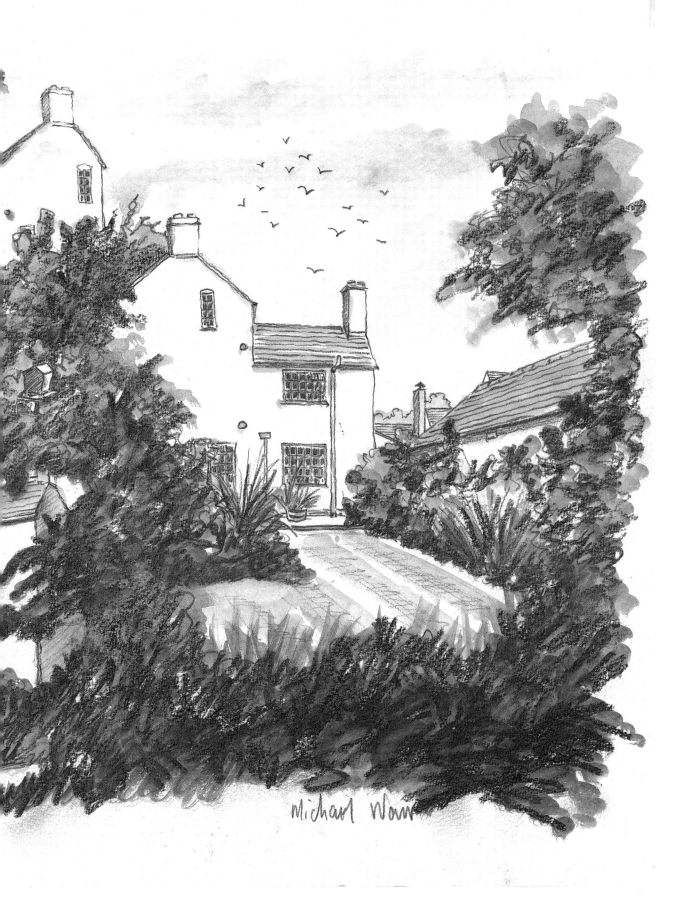

Michael Warr

LOOKING AT COLOUR

THE WORLD CONTAINS such a wide range of colours, at times broken down into very slight variations and the subtlest of hues and greys, that even in a high-tech age it is impossible to reproduce all those we see in nature. The challenge with a medium such as coloured pencils, therefore, lies in finding ways to convey the subtleties of the colours surrounding us with the comparatively limited range available in pencil, crayon or pastel form; the answer to this lies in the different ways of using and mixing them.

With pencils, crayons and pastels, colours can be mixed by hatching and cross hatching one colour over another, by blending or shading one into another, and by scumbling one layer lightly over another so that the colour underneath shows through. All these techniques are explained in Chapter 4.

However, colours also operate on each other in more subtle ways, and in order to understand these it is necessary to study their various characteristics and how they work.

Knowledge of colour related to tone, shade, light and dark is very important if progress is sought when producing artworks. Often dull, pale, unimaginative work results if the characteristics of colour relating to creating contrast, varying tones, light and shade and so on are ignored. The following examples are an introduction to understanding colour. Take time to study them – it will be time well spent.

ARTISTS' TIP

The primary colours are red, yellow and blue. The secondary colours – orange, green and violet – are produced by mixing the primaries. Tertiary colours are created by mixing primary and secondary colours.

Lymington Harbour

KEVIN KEMBER

Water-soluble coloured pencil on Arches 300gsm (140lb) watercolour paper

In this harbour scene, in which the bright splash of colour on the mainsail provides the focus of attention, wet and dry pencil techniques have been combined. The red, yellow and blue on the sail have been retained in their dry form – water is added to the surrounding areas.

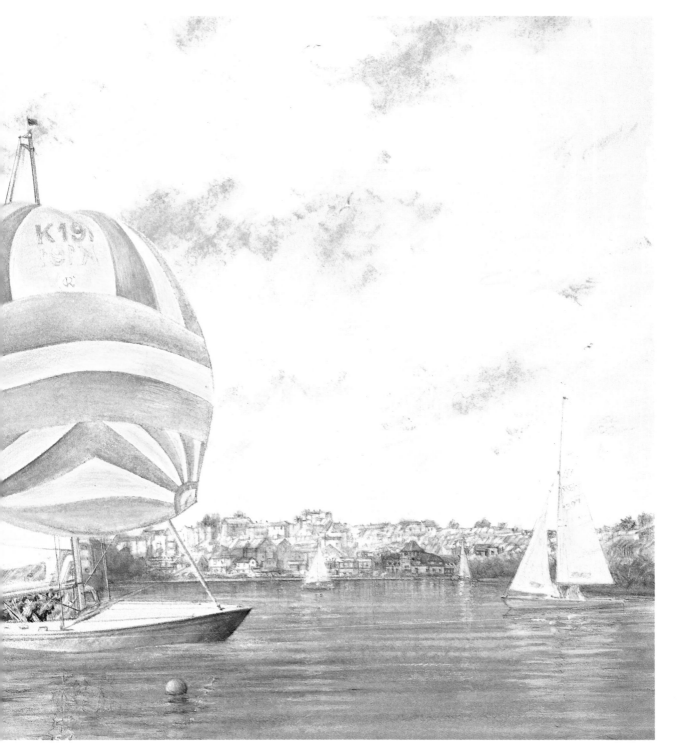

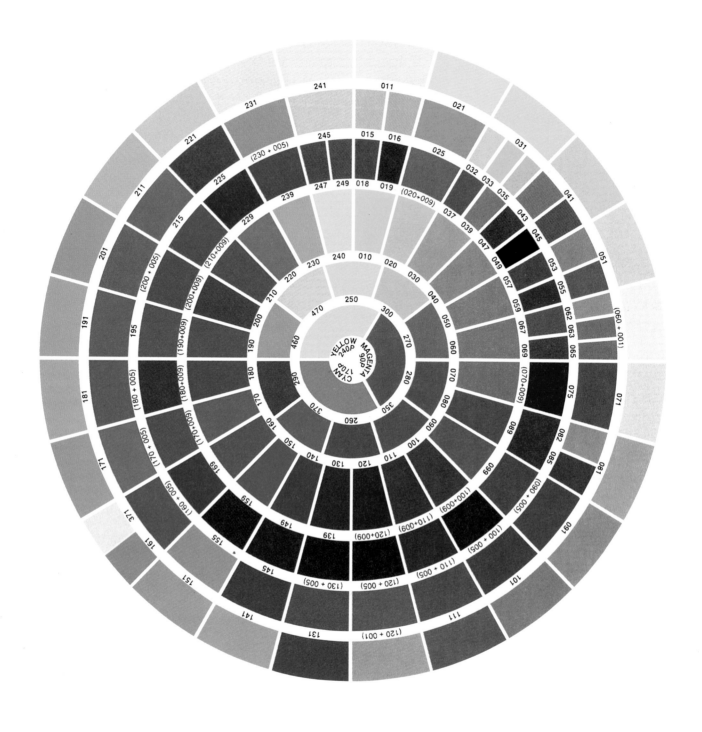

◁ *The Caran d'Ache colour classification system has been developed from the chromatic colour circle produced by Wilhelm Ostwald (1853–1932). At the centre are the three primary colours: Yellow (240P), Magenta (090P) and Cyan (170P). By mixing these three colours almost any shade can be obtained. The two inner circles comprise the Caran d'Ache range of pure prismatic colours, numbered with the terminate decimal 0 (zero). The shades in the outer circles are derived from pure colours darkened with black (terminate decimal 9), blended with grey (terminate decimal 2, 3, 5 or 7) or heightened with white (terminate decimal 1).*

In addition to the regular Caran d'Ache colour assortment, many other shades may be obtained by blending; the bracketed numbers indicate these.

HUE

Hue is the name given to a colour: red, yellow, blue and so on. Mixed colours are also hues; if blue and yellow are mixed, the new colour, or hue, is green. The colour wheel illustrates the primary colours (centre), the complementary colours (opposites), and the adjacent colours in their correct spectrum order. White, black and some greys are described as neutrals rather than hues.

TEMPERATURE

Colour temperature refers to the tendency of some colours, such as reds and yellows, to appear 'warm', while others, such as blues and greys, are deemed 'cool'. Generally speaking, when we look at coloured drawings and paintings, warm colours advance and cool ones appear to recede. This fact is especially helpful in the case of landscape drawings, as cool colours used in the distance can help to suggest a receding background.

TONE

Tone refers to the lightness or darkness of a hue as compared to a scale of greys from black to white. An understanding of tone is essential for describing form, as forms are revealed through the way in which light and shadow fall across them.

Tonal contrasts are just as important in colour work as they are in monochrome drawings. Strong contrasts between light and dark create interest and draw the eye, while the playing of light against dark and dark against light – known as

counterchange – can be used throughout a drawing, in a less strongly contrasted way, to define features and forms.

The manipulation of tone can also be used to evoke mood and atmosphere. Strong contrasts will create strong, bright light and deep shadow. A drawing made with predominantly light tones will evoke a light, airy or misty atmosphere, while predominantly dark tones can be used to create a sombre or mysterious mood.

△ *An example of colours with different temperatures. Note how the cooler grey 005 (top) appears to recede, while the warmer orange 030 (bottom) appears to advance. This visual phenomenon is useful to remember when producing landscapes. Great depth can be obtained by using warm and cool colours in a composition ie pale blue-grey mountains in the background and warm yellow-greens and browns in the foreground.*

△ *Here we see the tone (lightness or darkness) of Pink 081, being established by comparing it with Medium Grey 005.*

△ *The intensity or brightness of a colour (see overleaf), sometimes referred to as chroma, can be controlled in different ways: by varying the pressure of pencil strokes (left), Carmine 080; by adding a lighter colour over the top (middle), White 001 over Violet; or by adding a darker colour over the top (right) Black 009 over Cobalt Blue 160.*

INTENSITY

Intensity refers to the brightness, or 'chroma', of a colour. Pure, unmixed hues usually have a simple, brilliant quality. If a colour is too intense or brilliant, another hue may be overlaid to dull or 'tone down' the original colour. 'Dull' is not used in a derogatory sense here; it is a way of expressing the opposite of bright.

WHITE, BLACK AND GREYS

White, black and greys are described as neutrals or achromatic colours. Mixed with other colours, they will alter the values or intensities of those colours.

The tonal value of a dark colour can be lightened by overlaying it with white; this is a useful

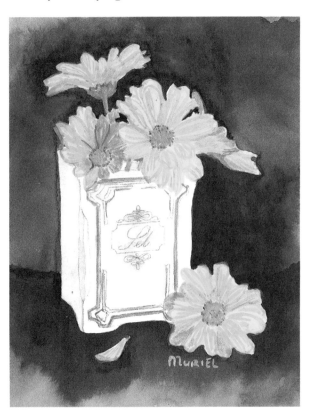

French Salt Pot with Daisies

MURIEL SMITH

Water-soluble pencil and crayon on Bockingford 300gsm (140lb) watercolour paper

Using a combination of water-soluble pencil and crayon, the artist has chosen to portray yellow daisies against a vivid blue background. The stark contrast between these two almost complementary colours produces a dramatic image.

technique for conveying glazed surfaces such as pottery or embossed glass. If black is overlaid on a colour, it will darken that colour's tonal value. However, take care when using black, as it is easy to deaden a hue, and 'kill' the intensity altogether.

COLOURED GROUNDS

When colours are applied to coloured or toned grounds – these can be either coloured paper or paper that you have prepared with an overall watercolour wash or, for an opaque ground, a gouache or acrylic wash – interesting visual effects occur. The colour temperature, tonal value and intensity of such grounds all influence the colours applied on them. For example, mid-toned colours will look lighter on a dark ground and darker on a light ground; a cool colour will look very cool on a warm ground. A ground of one colour will intensify its complementary if that is laid over the top, while lessening the impact of similar colours. Where the ground is allowed to show through in small areas, it will be affected in the same way by the colours and tones laid over it.

Neutral colours and similar tones are the most readily influenced in this way.

SITUATION OR REFLECTED COLOUR

The colours that you see in an object will vary depending on its location. Thus the 'local colour' of an object is its underlying recognisable colour: a green vase, red apple or purple telephone. The term 'ambient colour' is given to the colour or atmosphere surrounding an object: a grey wall, blue sky or yellow surface. 'Reflected colour' is that which is picked up by the object from the surrounding ambient colour, and this modifies the object's local colour.

ARTISTS' TIP

Try out colours on a piece of scrap paper that matches the paper you intend to use to make sure that they will create the effect that you want in terms of tone, brightness and temperature. Do this before you begin a drawing, and in the course of its execution.

△ *These three greens from the chromatic colour circle (page 20) – Light Olive 245, Grass Green 220, Dark Green 229 – represent a light, mid-tone and dark green.*

△ *Different pencil pressure from light to heavy produces a light, mid-tone and dark version of Violet 120.*

△ *A colour can vary in appearance depending on the colours laid down, or placed, around it. Here the red looks slightly brighter when surrounded by green – its complementary – than surrounded by blue. It is worth experimenting with other colours in this way in order to discover the optical changes that take place.*

EXERCISE TO TRY

Place a collection of natural and man-made objects – such as leaves, fruit and a teapot – on a surface. Try matching their colours as closely as you can with your own collection of pencils or crayons. If you have trouble deciding on the colours in the subject, ask yourself how they compare with the colours around them. If you are observing green, for example, is it a light green or a dark green, and is it a warm yellow green, a cool blue green, a grey green or a brown green? Once you feel confident select a pencil, or a combination of pencils, that enable you to match the colour as closely as possible.

△ *The effects of placing colour on coloured paper are seen here. The colours are at their purest on white paper. They are duller on similar colours and brighter on colours that provide a contrast. The colour of the paper also mixes with and alters the colours where it shows through: the yellow stripe is green on the blue paper, and the pale green is blue-green. The tone of each stripe alters as it travels across the different papers, looking darker against light papers and lighter against dark papers.*

Coloured Collage

Pablo coloured pencils on black Canford paper

This simple exercise uses the primary colours, red, blue and yellow. Liberal amounts of coloured pencil are applied to cartridge paper. The areas of colour are then cut into random shapes and stuck onto black paper. A black background provides dramatic colour against which the primary colours contrast well. Lay out the random cut-outs first in order to arrange them into an interesting composition before sticking them onto paper.

EXERCISE TO TRY

For each type of pencil, crayon and pastel that you have, make a colour chart. For each medium, apply a swatch of each colour to a sheet of paper and write its name beside it. This will be very useful when your colours have worn down, because you will then know exactly the names of those you need to replace. It will also give you a chance to get to know the colours in your collection, and to make a direct comparison between different media in terms of the density and brightness of colour, textural qualities and degree of opaqueness or transparency. This knowledge will help you to fully express yourself through your work.

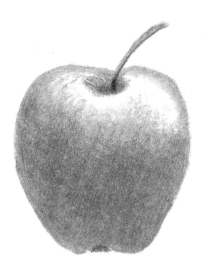

An apple depicted in its local colour tends to be rather flat if it floats freely in space.

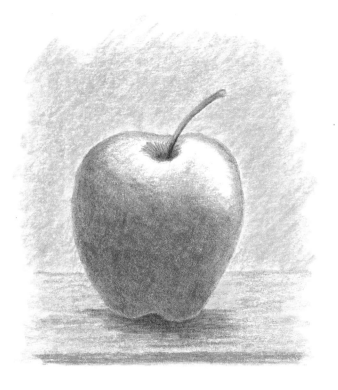
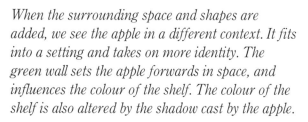

When the surrounding space and shapes are added, we see the apple in a different context. It fits into a setting and takes on more identity. The green wall sets the apple forwards in space, and influences the colour of the shelf. The colour of the shelf is also altered by the shadow cast by the apple.

Colour from the green wall is reflected onto the shelf, and from there onto the apple, as is colour from the shelf. Even shadow colour created by the apple is reflected back onto it. All these features combine together to give the apple a three-dimensional quality.

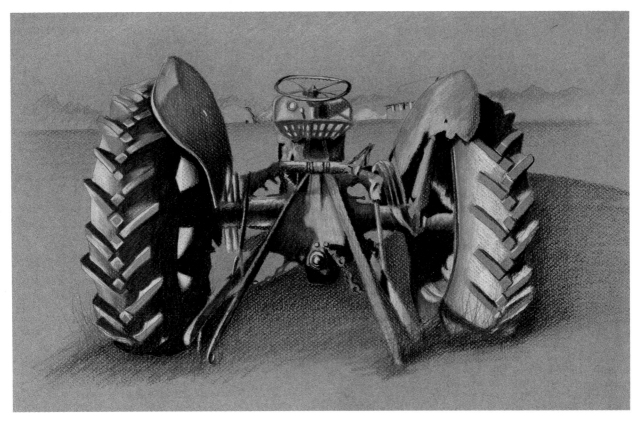

Abandoned Old Massey

ANDREW SUTTON

Pablo coloured pencil on tinted Canson pastel paper

Rusty old tractors provide a subject with unusual colours and interesting abstract shapes formed by the bodies, mudguards and tyres. This drawing was made on a bright February morning in an intense yellow light. Areas of deep tone and strong colour have been built up to suggest the strong light, and the lilac creates a feeling of its coldness.

Art Deco Lanterns

MURIEL SMITH

Water-soluble coloured pencil on Bockingford 300gsm (140lb) watercolour paper

The colour in the Art Deco jug – orange – provoked the idea of using something else that contained the same colour; the Chinese lanterns were the perfect answer. This approach gave the opportunity to use a close colour harmony throughout the composition to unify it.

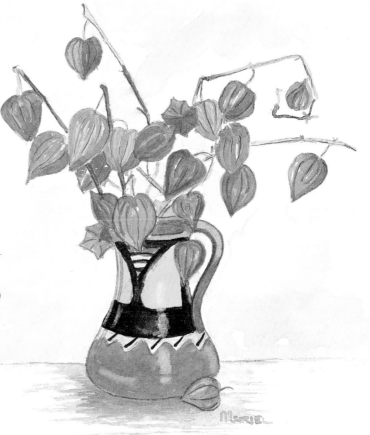

SUITABLE SURFACES

COLOURED-PENCIL WORK may be produced on a wide variety of surfaces, and the choice is further extended if you use water-soluble and turpentine-soluble pencils and crayons.

Greater demands are being made on manufacturers of fine-art surfaces to increase their standards of production as non-toxic, acid-free papers and boards are increasingly sought by an ever more discerning public. This is good news for artists, because increased quality of surface will ensure a longer life-span for the work produced. In many cases, a guaranteed permanence of pencil work can only be as good as the surface upon which it has been created. Although at this stage you may be more concerned with developing skills than with the permanence of your drawings, you should bear in mind that the appearance of a finished drawing is dependent on the quality of the materials used and on the type of surface chosen. Very often, students are disappointed with their work, only to discover that, after seeking advice, a wiser choice of surface could have made a substantial difference.

TYPES OF PAPER

Paper provides a good surface or support for all types of pencil work. Good quality cartridge papers are widely available and are not too expensive. It is normally better to obtain them from your local art store, where you will find a comprehensive range. Avoid thin, cheaply produced, so-called children's sketchpads because inexpensive purchases can turn out to be suitable only for shopping lists. This opinion is not meant to suppress creative and experimental ideas. If you feel like drawing on wrapping paper, do so; but make sure that it is strong enough to support your work!

Watercolour papers, both smooth and textured, provide excellent surfaces for coloured-pencil work. The paper texture can be used to great advantage when working with dry, soft pencils or crayons. Bricks, rocks and weathered wood, for example, can be conveyed successfully by allowing a textured surface to do some of the work. If water soluble coloured pencils are used, watercolour paper, designed to cope with liberal applications of water, is obviously a good choice. Some watercolour papers are mounted onto dry card, providing excellent support for dry or water-soluble work.

Tinted pastel papers are interesting to use; pale colour is provided immediately, setting the ambiance of the piece. Coloured mount card is another possibility. It is often available at framing shops in the form of off-cuts, providing an inexpensive source of supply. Illustration board is available in different finishes and makes an excellent surface for coloured-pencil work, especially if you want to apply several layers of colour because it will take strongly applied strokes.

UNUSUAL PAPERS

Other suitable surfaces offering exciting possibilities include brown wrapping paper, strawboard, sugar paper, cardboard, wood and fine sandpaper. The only thing to bear in mind is that the further you move away from recognised fine-art surfaces, the less permanent the surface is likely to be.

If turpentine-soluble crayons are being used, oil sketching paper is strongly recommended. The surface is suitable for oil-based products, and will take thick or diluted colour. If cartridge paper or illustration board is used, the oil content of the crayons will 'spread', forming an unwanted 'halo' around the image. Ready-prepared boards for oil painting are acceptable for use with oil or wax crayons, or you could prepare a suitable acrylic paper with acrylic primer. The primer can be applied to thick cartridge paper, watercolour paper, mount card or illustration board.

PAPER SURFACES

CARTRIDGE PAPER

Good quality cartridge paper is supplied in single sheets, on large rolls or in pad form, and all are available in a range of sizes. Heavier grades or weights are best suited to coloured-pencil drawing because they have a slight surface texture or 'tooth' that picks up colour from a pencil better than completely smooth papers. Drawings which are made on very smooth surfaces seem to lack character for this reason. The most convenient way to purchase, use and store paper is in pad form. Single sheets can be removed as desired, or the pad can be kept intact, providing a useful sketchbook. Whichever size you decide to use for your work, remember that quality is the most important criterion.

When a drawing on cartridge paper has been completed, it can be dry-mounted onto card to provide rigidity prior to framing.

If water-soluble pencils or crayons are being used with water to create washes, heavy grades of cartridge paper should be 'stretched'. Soak the paper under a tap, then lay it flat on a drawing board and wipe it with a tea-towel to absorb excess water. Secure the paper to the board on all four sides with strips of gummed tape and leave it to dry. The wet paper stretches, and is kept at full stretch as it dries, so it will not cockle when colour washes are applied to it.

WATERCOLOUR PAPER

Lightweight watercolour papers need stretching – this process is described above – if large amounts of water are applied; very heavy papers can be used without stretching. The minimum weight that does not need stretching is 300gsm (140lb). Apart from differences in weight or thickness, watercolour paper is produced in two very distinct types: machine-made and hand-made. Machine-made papers tend to be predictable by their very nature: their standard quality can be relied on, and they will always perform in the same way each time they are used. After trying out a number of papers, it should be possible to choose two or three that suit you and which will never let you down. Knowing how a paper will perform is invaluable when you are producing work for an exhibition or on commission, when you might not have the time to experiment.

Machine-made papers are produced in a wide variety of sizes, weights and finishes. The finish of a paper refers to its surface quality. There are currently three machine-made surface types available. These are: NOT (medium texture), hot-pressed (quite smooth), and rough (rough texture). All three are suitable for dry and water-soluble pencils.

Hand-made papers are available in the same finishes, but there are many more alternatives due to the individuality of hand-made processes. True hand-made paper is produced in a mould, one sheet at a time. Obviously, being such a labour-intensive method of production means that hand-made papers are going to be more expensive. The very best ones are produced from rag fibres and do not contain any woodpulp. Well produced, hand-made papers exude a feeling of luxury, and often provide the ideal surface for both dry and water-soluble

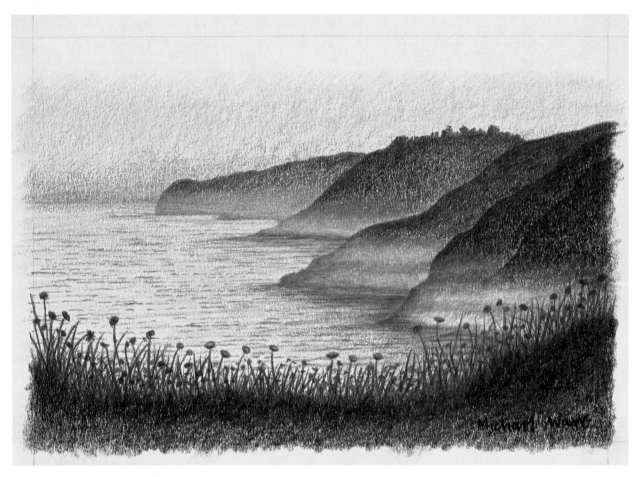

coloured-pencil work. It is worthwhile investing in a sheet or two, just for the working experience!

COLOURED PAPERS

Coloured and tinted drawing paper is produced by a number of manufacturers. Some papers are designed especially for crayon or pastel work. They have a fine tooth and are ideal for coloured-pencil drawing. If water-soluble pencils or crayons are used, these papers will need to be stretched in the same way as cartridge paper. Be careful to select only papers produced by well known, reputable manufacturers, as some coloured papers are not lightfast, so will fade over a period of time. Coloured or tinted papers may need dry-mounting onto card before framing.

CARD AND BOARD

Mountcards or mountboards are used by picture framers to surround works in picture frames. They are produced in a wide range of colours, including black and white. The better quality boards are acid free, and many have a slightly textured surface, making them ideal supports for coloured-pencil work. Mountboards can be purchased either as single sheets or in packs from your local art store. It is sometimes possible to obtain off-cuts from picture framers, providing a cheap source of supply.

ILLUSTRATION BOARD

Available in various finishes, sizes and thicknesses, illustration board provides an excellent surface for all types of coloured-pencil work. The extra thickness ensures that heavy pencil pressure can be applied without fear of cutting through the surface, and there is no need for stretching when water is used. Illustration board is primarily intended for use by graphic designers, and as a result the surface tends to be fine textured, but many manufacturers also produce watercolour boards. These consist of watercolour paper dry-mounted onto thick card. Rougher textures are available, if required, and again these boards dispense with the need for stretching. Watercolour boards are available in a range of sizes, but illustration board tends to come in larger sizes only, although this need not be a problem as it is easy to cut the board to the desired size with a craft knife.

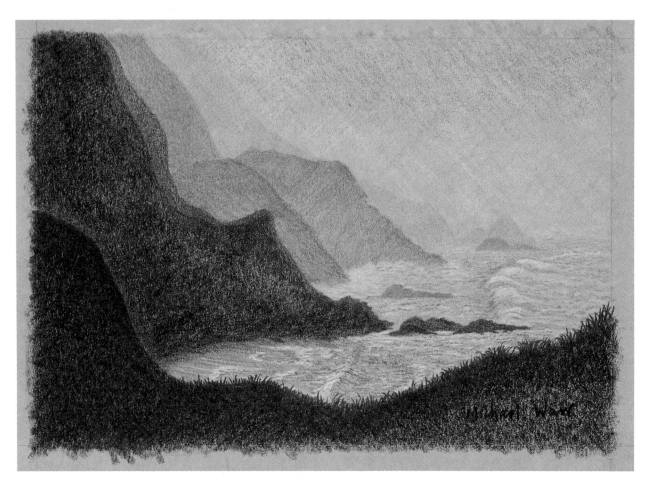

Sunset, Big Sur and *Heavy Weather, Big Sur*

Coloured pencil on tinted paper

These two compositions are based on the same area of the Californian coast, and illustrate the use of coloured papers to convey different atmospheres.

Sunset, Big Sur is produced on a warm, yellow Canford paper. Light hatching with yellow, red and violet is employed to depict the brightly lit sky and the reflections in the sea, providing light areas against which the cliffs and mountains contrast well. The bands of mist around the base of the cliffs are created by burnishing with white. Very dark colour in the foreground suggests distance because it pushes back the sea and cliffs.

Heavy Weather, Big Sur is presented on a cool, light grey Canford paper because a wet, misty effect is desired. Colour is applied by crosshatching, and is then burnished with white to convey the lighter sky and distant cliffs. These remain light and misty, while the nearer cliffs and foreground are much stronger. This contrast provides the picture with drama, which is necessary when creating adverse weather conditions. Crosshatching of heavy dark blue, sepia and slate grey create a moody, brooding foreground, over which the rough sea can be viewed beyond.

ARTISTS' TIP

You can create your own tinted paper by rubbing charcoal or soft pastel over the paper and then rubbing it gently into the surface of the paper with cotton wool.

This works well on smooth or lightly textured papers, but with rough papers it is difficult to work the colour into the pits in the surface.

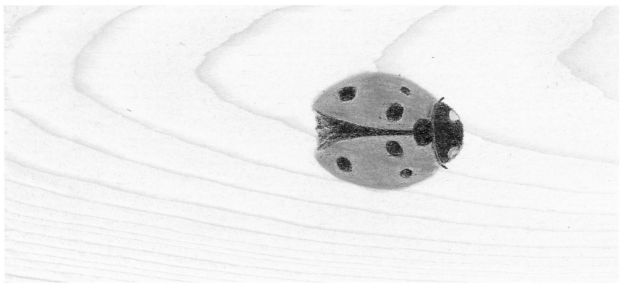

Ladybird

Pablo coloured pencil on wood

*B*ecause the pigment content of Pablo pencils is of a very high quality, they are ideal for drawing onto wood, such as this ladybird 'resting' on a piece of pine. It is possible to decorate furniture with coloured pencils provided that the pigment content and quality is good. The finished drawing can be varnished, which protects it and at the same time seals the wood. This technique is rather more successful if the drawing is made on untreated timber; polished or varnished surfaces will not allow the pencil pigment to adhere to achieve a satisfactory finish.

◁ ## Cloud Study

Neopastel on blue Canford paper

*P*astel lends itself well to conveying ethereal atmospheric conditions. This study is based on a drawing by the Genevese artist, Alexandre Calame (1810–1864). A limited range of colours can be explored on a coloured surface; here only black, white and violet are used. There is little colour mixing – the result relies on effective use of contrast.

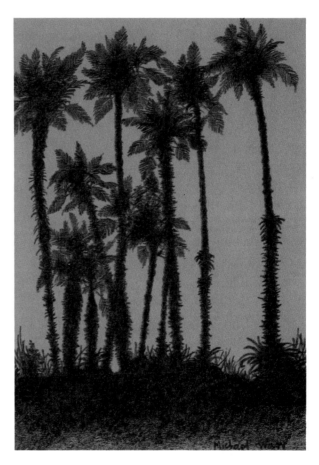

△ ## California Sunrise

Coloured pencil on Canson paper

*D*ramatic contrast is expressed in this study of Hollywood trees seen against a red background, which is provided by the paper. Black is the only colour used as this provides enough intensity and contrast with the rich red of the Canson heavyweight paper. Light strokes are applied initially, followed by stronger crosshatching. It is quite easy to create drama by choosing a coloured paper that contrasts with the pencil colour.

EXPLORING TECHNIQUES

B Y EXPLORING THE techniques of coloured-pencil work and related media, you can gain valuable experience of the most appropriate ways of using different pencils and crayons to create the effect you want. Interesting work results from the use of sound techniques combined with sensitivity and creative ideas. It is not easy to balance the two aspects, but constant practice will enable you to produce surprising results.

SIMPLE TECHNIQUES

If you do not feel confident about your drawing skills, but an open box of well arranged, beautiful coloured pencils inspires you to have a go, there are some easy ways to make a start, and from these you may well discover that your skills are greater than you had

realised! Some of the following ideas may also be interesting to readers with more experience of this media.

Two examples of stencilling with coloured pencils. The flower is a very simple exercise, in which single layers of flat colour are applied. In the bunch of grapes, extra depth is achieved by layering one colour over another. Double-sided, low-adhesive sticky tape can be used to hold stencils in place. Start with a light pressure on the pencil, gradually increasing it until you have the desired shade or colour. Try to keep the pencil strokes moving in the same direction in all parts of the design to begin with as this will give unity to the image and increase its impact.

STENCILS

Stencil work is probably the simplest way in which to begin using colour. A shape is already created for you, and to produce an image on paper all that you need to do is select a colour, or colours, and apply them within the stencil shape. The thickness of the stencil material will ensure that your pencil remains within the shape of the stencil. Stencils are often used in conjunction with paint, but unless the colour is handled with care there is a tendency for dilute paint to seep under the stencil, leaving traces of unwanted colour. This problem does not occur when a pencil is used.

The stencil method enables students with little or no experience to produce such items as greetings cards, letterheadings and party invitations. If artists' quality coloured pencils are used, it is possible to apply the stencil method to furniture and wall decoration. With more experience, water-soluble crayons and pencils can also be used for stencil methods of application.

FROTTAGE

Frottage is a term derived from the French verb *frotter*, to rub. It is another technique that requires no particular drawing skills. All you need do is select a textured surface, place a piece of paper over it and rub with a soft coloured pencil. Surfaces with easy access include coins, cake doilies and wooden floorboards. Textures taken from surfaces can be used as backgrounds for drawings. Thinner papers are best suited to frottage techniques. Your local art store should have suitable papers, usually in a wide range of colours.

EXERCISE TO TRY

Set up a simple subject such as a plant or a still life with two or three objects and make a series of drawings, each with a different media, in order to discover what can and cannot be done with each. Choose very different materials and also try one or two techniques such as sgraffito and stencilling. If you persevere with one subject you will get to know it really well, and this will free you so you can concentrate on capturing different aspects of it with different media and techniques.

ARTISTS' TIP

All the media are compatible with each other, so don't hesitate to combine them if this will give you the effect you want.

Two simple techniques – frottage overlaid with stencil work – are combined in this flower design. The background texture is created by rubbing colour onto paper laid over the textured side of a piece of hardboard. The hardboard is then removed and the drawing is placed on a board. The stencilled image is produced using just a few colours and blending them to create shaded areas.

Three examples of frottage:

A fan shape produced by rubbing over a shell.

This fan shape is created by rubbing over a plastic drinks mat.

Rubbing colour over a medal created this interesting image. Coins and medals provide excellent frottage material.

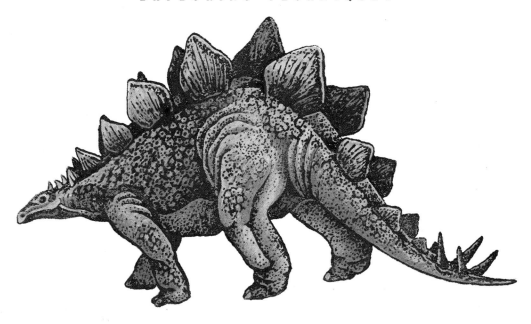

RUBBER STAMPS

Many types of rubber stamp are available, produced with the activity of colouring in mind. The subjects are already created, and all that is necessary is the addition of colour. Both dry and water-soluble coloured pencils are suitable for use with rubber-stamp images. There is a huge range of subjects available, including film stars, animals, cartoon characters, vehicles of all types, flowers and buildings. The choice is endless and you can have great fun with them! Possible applications include designs for letterheadings, for party invitations and greetings cards.

△ *Rubber stamps provided the images for these illustrations. A few colours have been used in each case, but there are no hard-and-fast rules. One colour or ten can be used; the choice is yours! It is possible to soften the intensity of solid ink areas by working over them with a pencil. Because coloured pencils are semi-opaque, they possess excellent covering power. However, it is a good idea to retain the intense outline of a rubber-stamp image, as this will provide a certain crispness, adding impact to the finished piece of work.*

SILHOUETTES

Silhouettes will stretch your drawing skills a little further as they require some freehand work. Simplicity is still the keynote, because only shapes need to be reproduced, rather than detail and form. They consist of dark shapes seen against a light background, such as a dark city skyline against a sunset sky. The artist controls light and dark in drawing so any shape in the composition can become a silhouette.

A silhouette can be produced by using a black or very soft graphite pencil on white paper or card, but rather more subtle effects can be produced by overlaying two or three colours, creating a silhouette with extra depth. If coloured paper or card is used, interesting visual effects will occur. Background colours can also be created using coloured pencils of a light hue or water-soluble colour applied in the form of a light wash.

Two examples of silhouette work showing the use of limited colour.

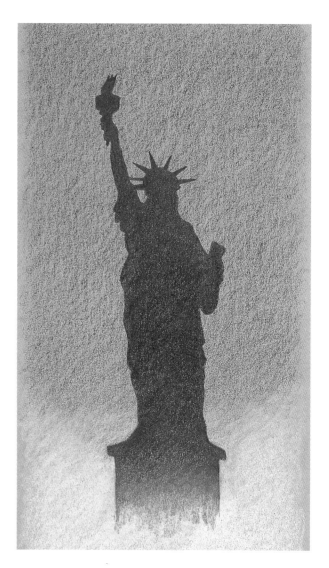

Liberty in the Morning Light

Coloured pencil on tinted mountboard

Chosen for instant recognition, a silhouette of the Statue of Liberty in the entrance of New York harbour provides a simple shape with strong visual impact. The colours of a morning sky, applied to a pre-coloured surface, create an interesting background. Two colours are overlaid to produce the shape of the statue. Rising mist around the base is depicted with pure white, but this is slightly diffused because the surface is pre-coloured.

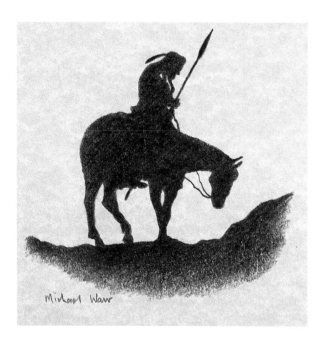

Native American

Coloured pencil on tinted mountboard

Two colours only are overlaid on a tinted and textured surface to create a strong image. Although there is no form or detail, the simple shapes are instantly recognisable.

38

MECHANICAL AIDS

Many different drawing instruments are available, ranging from a simple ruler to French curves, set squares, compasses and spring-bow dividers, and they can be of great assistance in producing coloured-pencil drawings and designs. Professional graphic designers would not be without them, but they are sometimes frowned upon by the traditional fine-art world. On the other hand, modern artists, particularly those concerned with abstract and constructivist work, have used drawing instruments extensively. Artists to look out for are Ben Nicholson and Wassily Kandinsky.

Drawing aids offer the beginner a way in which to produce simple shapes for practising with coloured pencils. As experience increases, however, it is better to dispense with them, especially if freehand drawing is desired.

All the shapes in this piece of work are produced with the aid of drawing instruments: a ruler, compasses, French curves and a protractor. An exercise of this type enables you to try out colours by filling in simple shapes. It is also possible to discover what happens visually when certain colours are placed beside each other. In this case a little shading is used to give some of the shapes a three-dimensional effect. Abstract compositions of this nature can be great fun to make, and they provide you with ideal coloured-pencil drawing experience.

GENERAL TECHNIQUES

Let us now explore some of the exciting general techniques associated with coloured pencils, water-soluble pencils and crayons. Pastel and oil crayon techniques will also be explored. There are many possibilities at our disposal and it is important to investigate several fields of creativity as this is the way in which we discover the potential in a medium as well as in ourselves. Always keep an open mind on what might be achieved by taking a medium to the limit of what it can do in order to discover new ways of working. It is very easy to become encased in a strait-jacket, to lose your sense of adventure, thus losing the capacity to use a medium both intellectually and creatively. Let your ideas sing and enjoy what you do!

Hatching

Making strokes with a coloured pencil is one of the basic methods of drawing. The spaces between the strokes allow the paper to show through.

Crosshatching

A stronger image is produced by hatching in one direction, and then adding another layer of hatching in the opposite direction over the top.

Multi-crosshatching

Multi-crosshatching, done by layering several colours, begins to build an interesting texture or pattern, making the resulting image much richer in appearance. This type of layering can continue until you have the depth of colour or tone that you want. This is a good way to produce mixed colours and greys with coloured pencils.

COLOURED PENCILS

A broad range of marks and effects can be made with coloured pencils. Densely packed short strokes can be used to block in areas of colour. Layers of colour can be built up using the point of the pencils, hatching and crosshatching one layer over another with longer strokes. The pencil can also be used on its side to put in areas of shading. To create even shading, rest your little finger on the paper and swing your hand back and forth with an even pressure and rhythm. A light colour can be burnished over a darker colour in order to lighten it, producing a dense but diffused area of colour. Or the pencil can be used to produce a variety of lines, scribbles, dots and dashes as appropriate to convey the pattern or texture of the subject.

Strokes

Short pencil strokes made with grass green begin to produce a texture.

Yellow is introduced using the same short strokes. More of the paper is covered, but some still shows through.

Finally, ultramarine is used to complete the texture. The richness increases as each colour is applied, and the colours look as if they are woven through each other.

Intense hatching

Yellow is applied with very close hatched strokes; it is almost impossible to detect separate lines. The paper surface is dictating the texture, because colour is picked up on the 'hills' but the 'valleys' remain white.

Ultramarine is applied in the opposite direction. This process changes the hue and also increases the textural effect.

As russet is overlaid, the hue changes again and the texture becomes much richer. This technique is useful for blending colours and also for creating or suggesting the surface quality of a subject.

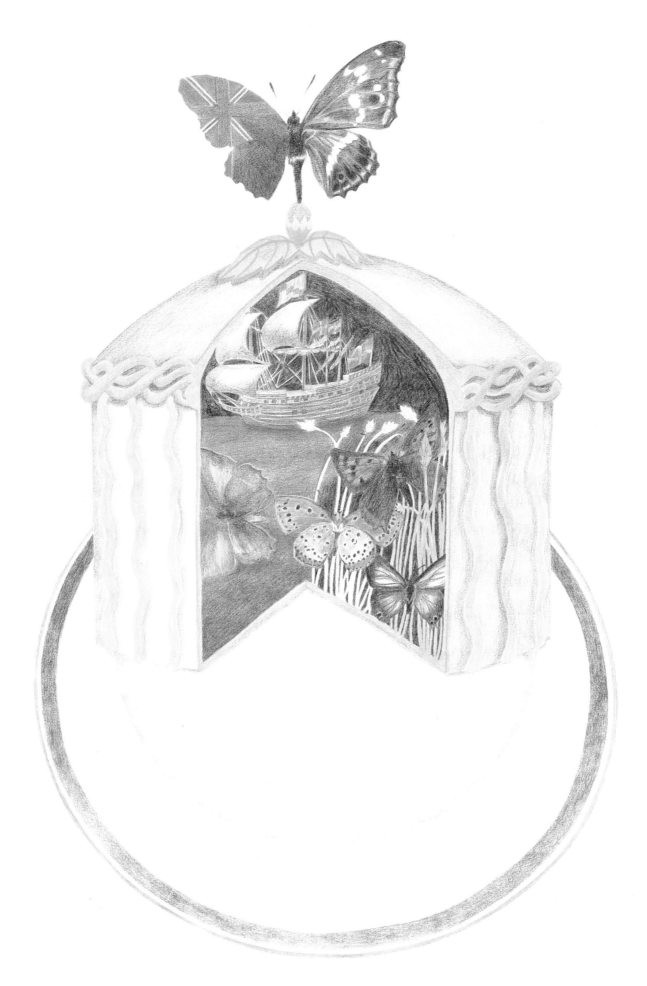

'The White Knight's Song'

MALCOLM DAVIES

Coloured pencil on cartridge paper

Inspiration and ideas for drawings can be derived from many sources. This illustration was inspired by a poem from Through the Looking Glass *by Lewis Carroll. The drawing has a surrealist feel about it as the butterfly at the top becomes a flag on one side, yet retains its normal markings on the right-hand wing. Inside the pie, we discover more butterflies, wheat and a sailing ship. These subjects are rendered by hatching and crosshatching colours, creating good contrast with the outer crust of the pie, which is drawn with delicate, light pencil strokes. Light pencil pressure is also employed to depict the design on the plate, which is important to the overall design of the illustration. Compositionally, a sensitive balance is retained throughout this very interesting piece of work.*

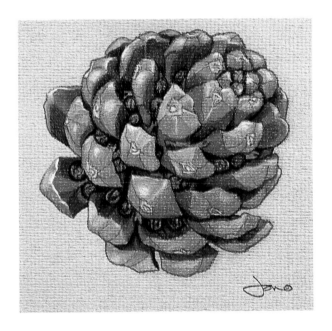

Cone I

JONATHAN STEPHENSON

Soft coloured pencils on Ingres paper

An excellent drawing of a pine cone produced with soft coloured pencils illustrates how well fine detail can be achieved with this medium. Tinted Ingres paper is used; the colour harmonises with the limited range of colours in the subject.

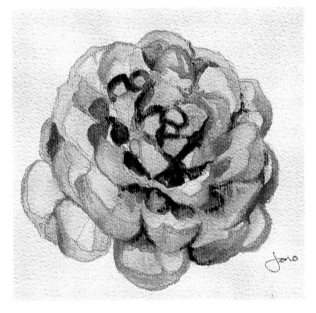

Cone II

JONATHAN STEPHENSON

Water-soluble pencils on watercolour paper

This pine cone has a much looser appearance than the drawing done with dry colour, and the colours have softened because water has been added to the colour pigment. In this instance, the artist dampened the paper initially and then drew with the pencils, a method that instantly produces diffused images.

Burnishing refers to the technique of making a heavy application of a light colour over a darker one. White is most widely used for this purpose, but any very light colour may be employed, depending on the circumstances and the artist's preference. The dark colour that is applied first establishes an overall shape and gives solidity and depth when the white or light colour is added over the top at the next stage; this mixes with it and lightens its tone. The light pencil should be applied firmly and can be rubbed with a tortillon to blend it back a little. Burnishing is a good technique for depicting effects such as mist and atmospheric haze in landscapes.

Burnishing

A heavy application of carmine is burnished with white.

A lighter application of carmine is burnished. Note how the burnishing appears to be lighter.

Violet is hatched over carmine and then burnished with white.

Black, applied heavily, is burnished with light grey.

A light application of ultramarine is burnished with white. In this case the effect is to bring out the underlying colour.

Yellow overlaid with ultramarine is burnished with white.

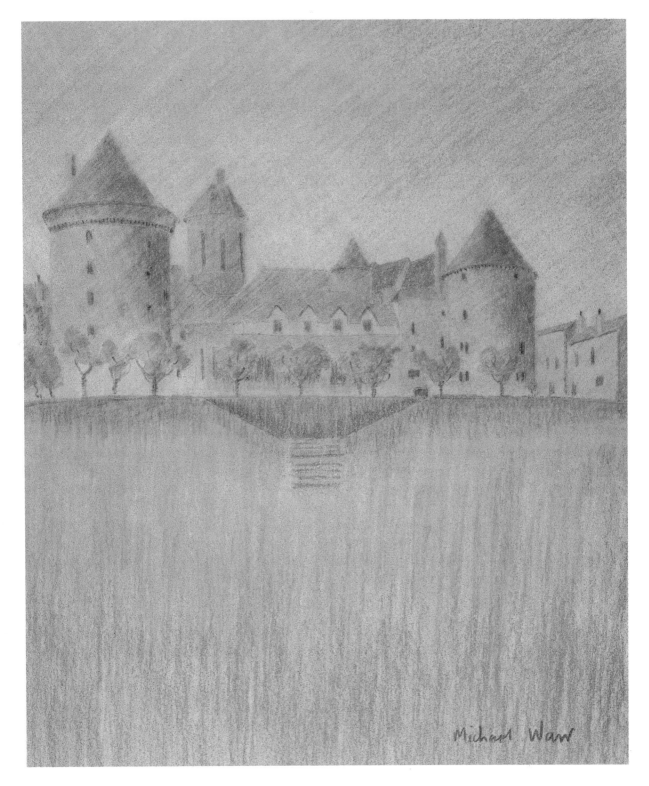

Early Morning, Bourganeuf

Pablo coloured pencils on Canford tinted paper

A good example of burnishing is portrayed here. Tinted grey paper provides the surface over which the buildings are drawn, first with strong colours. Yellow and crimson depict the sky – purple and crimson vertical strokes create the foreground. Light cream and white are then crosshatched over the entire surface in order to create misty effects.

WATER-SOLUBLE COLOURED PENCILS

Water-soluble pencils are intended to be used with water. They can be applied to dry paper and then dissolved and blended using a brush loaded with water, or they can be applied to wet paper. Because water is added to the pigments in each technique shown, watercolour paper is used as a support.

Ultramarine strokes are applied to a dry surface, and water is added with a brush. The pigment dissolves, but the lines are retained; there is no attempt to lose them as they form an important part of the technique.

Ultramarine and yellow are applied to a dry surface, and water is added with a brush. The two colours mix and take on the appearance of a watercolour wash.

A thumbnail sketch produced by wetting the paper and drawing onto the damp surface. All lines and areas of colour dissolve and spread slightly as the pencil lead touches the surface.

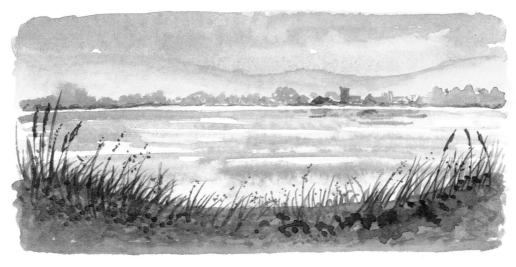

Four colours are applied down the side of the paper, and water is added to them with a brush to produce four pools of colour. The colours are then picked up with a brush and applied using traditional watercolour methods – wet into wet and wet over dry. The result is a small watercolour-like sketch. This technique can be used to create large works that resemble highly finished watercolour paintings. The better the quality of the pencils that you use, the brighter and stronger the results.

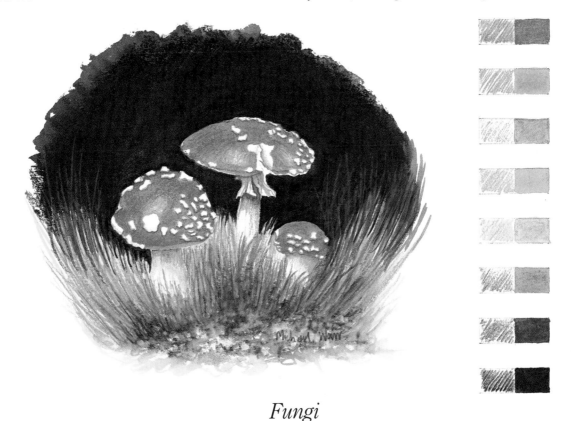

Fungi

Water-soluble coloured pencil on watercolour paper

Colourful fungi are drawn with water-soluble coloured pencils onto dry paper. The grasses are also drawn at this stage. Water is applied to dilute and intensify the colours, then allowed to dry. A mixture of dark brown and dark blue is applied to the background, and water is applied, producing a dark, rich effect that pushes the fungi forwards, giving the finished work strength and impact.

The colour swatches on the right indicate how dry colour is intensified when water is added.

WATER-SOLUBLE CRAYONS
Water-soluble crayons possess exactly the same characteristics as water-soluble pencils apart from the fact that they are much softer; they are, in fact, virtually sticks of watercolour paint. As with water-soluble pencils, they work better and to best effect when used on watercolour paper than on other types of paper.

Red is applied to a dry surface and water is added to it. The crayon lines virtually disappear with the addition of water, but some pigment is retained. This effect can provide useful textural qualities. The colour in its dry form and pure wet form are also shown.

Red and yellow crayon are applied to a dry surface. Water is added and the two colours blend to create orange. The two colours in their dry form, and the mixed colour in its pure wet form are also shown.

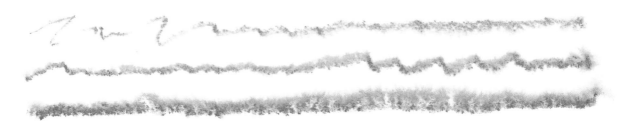

Crayons are applied to an already wet surface. As the crayon touches the surface, the colours diffuse

immediately. Soft images and shapes appear as work continues.

Blue and yellow pigments are applied to paper, and water is added to each to create pools of colour.

These colours can then be used for traditional watercolour techniques.

Masking fluid, which is normally associated with watercolour painting, is applied to create the flower shape. When it is dry, dilute crayon colour is washed over the top and allowed to dry. The masking fluid is then removed, exposing the white paper surface.

Dilute violet crayon colour is applied and left to dry. Then a brush loaded with clean water is washed over the area. This re-activates the colour pigment, and absorbent tissue is used to blot away the unwanted colour. It is possible to correct mistakes in your work by use of this technique, which is similar to lifting out with watercolours.

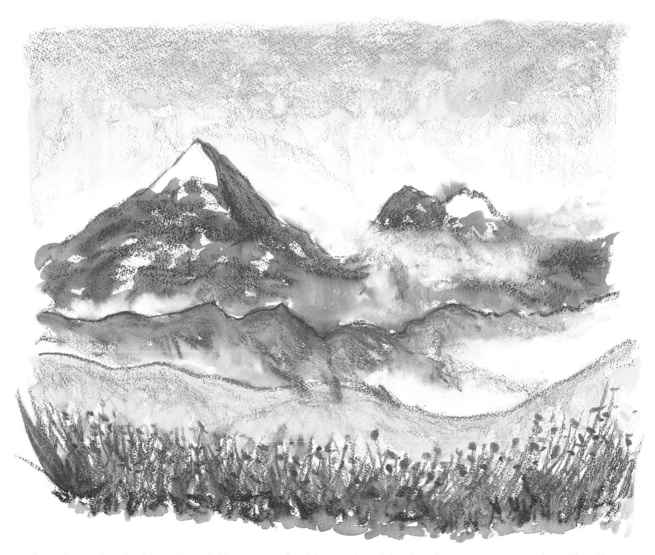

A study produced with water-soluble crayon. Applying water with a brush creates a watercolour-like effect.

WAX OIL CRAYONS

Wax oil crayons can be used dry, or with the addition of turpentine to dilute them. If you are using them with turpentine it is advisable to work on oil sketching paper, which is specifically prepared to accept the mixture of turpentine and an oil-based medium. The first two examples illustrated here are produced on oil sketching paper, while the other two examples are produced on a more heavy-weight cartridge paper.

Blue and yellow crayon pigments applied to a dry surface. Turpentine is added with a brush, resulting in the two colours mixing and adopting the appearance of dilute oil paint.

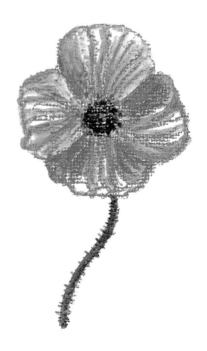

The poppy is drawn with dry crayon onto a dry surface. Turpentine is applied to the drawing with a brush, causing the pigment to diffuse and giving the sketch a soft look.

A yellow crayon is applied, and then a brown crayon pigment is applied over the top. A craft knife blade is then used to expose the underlying yellow colour. This technique is known as sgraffito.

Yellow crayon is applied to paper, and a wash of dilute water-soluble colour is washed over the top. The wax oil colour resists the watercolour and remains exposed. This method is often employed in watercolour painting.

△ *This abstract composition is based on seaside shapes. Water-soluble coloured pencils were applied to dry watercolour paper, and when the drawing was complete, water was added with a large, round, pointed Dalon brush to soften the colours and shapes and give them an overall unity.*

▷ *Abstract*

Water-soluble coloured pencil on Fabriano watercolour paper

This abstract design was inspired by shapes found in woodgrain. Notice how the shapes centre around the 'knot'. Brighter colours are used here, and water-soluble pencils provide them. Rough watercolour paper is heavily dampened and colour is applied; the colour diffuses immediately on the damp surface, but also increases in intensity as it dries. When the drawing is bone dry, the main shape is cut out and mounted on black paper, thus increasing its impact and interest.

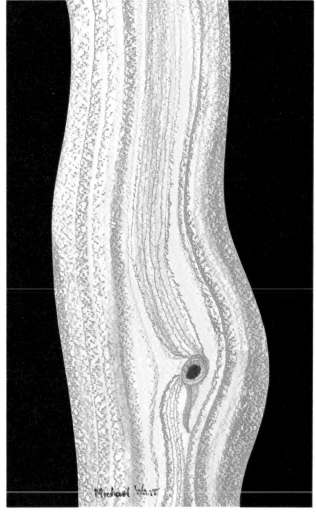

NEOPASTEL

Neopastel is fun to use and requires no fixing. Pastel drawing or painting tends to be more effective when the colour is applied to coloured or tinted surfaces. The examples shown below and opposite are produced on a medium grey Canford paper.

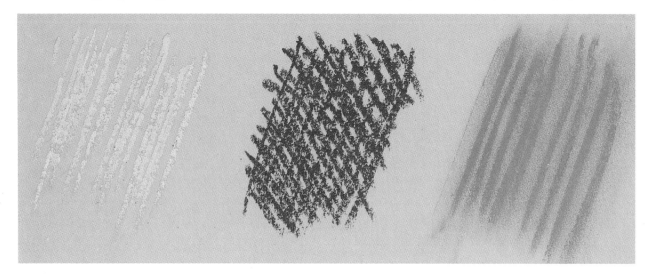

Hatched lines produced using the pastels on their edges.

Crosshatching creates a stronger, dense effect.

Soft tone produced by rubbing hatched lines with a finger.

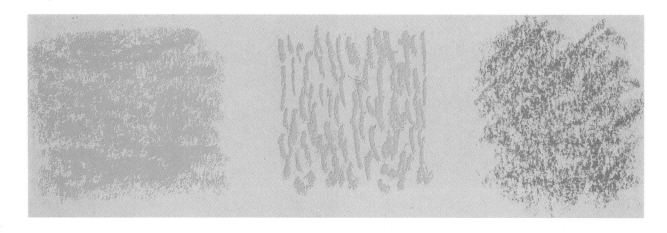

Colour applied with the flat end of a pastel following the paper grain.

Short strokes made across the grain of the paper.

Colour applied across the paper grain using the flat end of a pastel.

Reds, yellows and oranges applied with the end of the pastel form a pattern.

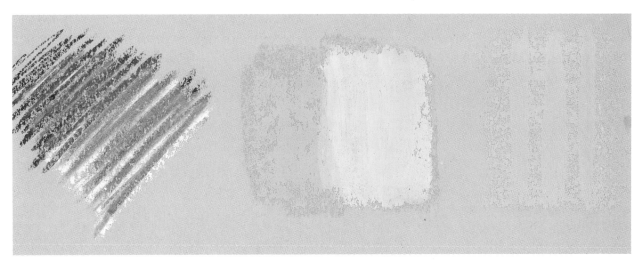

The effect of hatching with white over blue.

A strong application of white over a strong application of yellow.

An eraser pulled through the colour produces three vertical shapes.

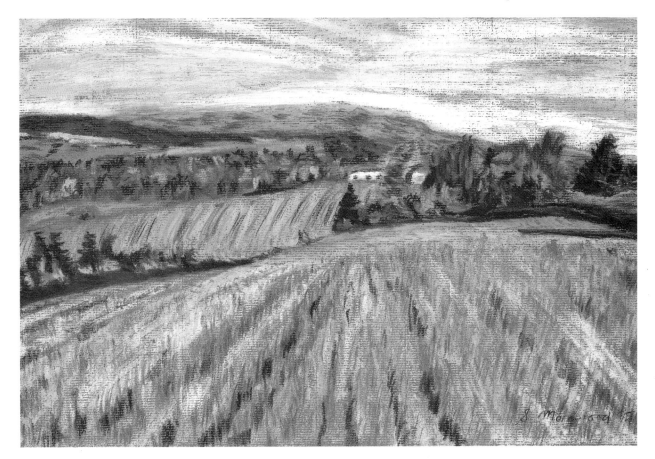

Provence

STEVEN MOREWOOD

Neopastel on tinted pastel paper

An exciting landscape is rendered using pastel in a very direct and bold way. We are taken back to the distant hills by means of 'lines' in the foreground and middleground fields. The sky, dramatically portrayed, becomes an important and integral part of the composition, creating a feeling of overall unity.

WATER-SOLUBLE GRAPHITE PENCILS
When used in their dry form, water-soluble graphite pencils look exactly like normal graphite pencils, but to fail to add water to them and thus explore all their possibilities would be a waste; they have brought another dimension to graphite pencil drawing. The same techniques can be used as with water-soluble coloured pencils.

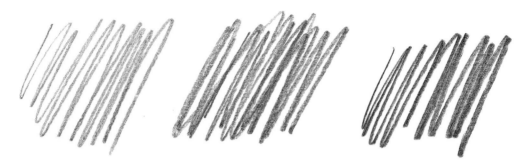

Three grades of graphite pencil hatched in their dry form. They are, from left to right, HB, B and 3B.

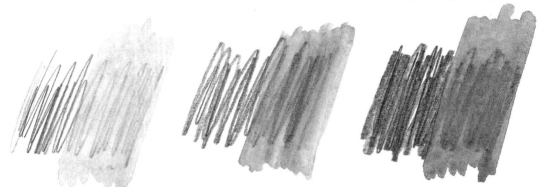

The same three grades diluted with water. Note that the much softer, 3B grade (right) is far more soluble and intense than the other two.

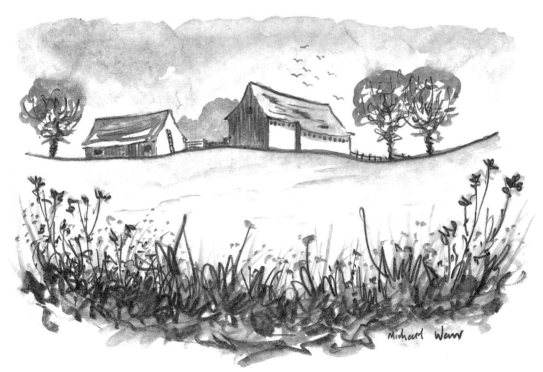

A sketch made with the 3B grade onto a dry surface. Water is applied, transforming it into a tonal study.

Storm Brewing

Mixed media on tinted pastel paper

In this moody composition water-soluble pencil, crayon, water-soluble graphite and wax oil crayon are combined to create interesting visual effects. After some initial drawing with a water-soluble graphite pencil, wax oil crayon is applied to create colour resist on the tree trunk. A mixture of water-soluble graphite pencil and Neocolor II water-soluble crayon are used to put in a stormy sky. The foreground shapes and textures are produced by spattering dilute water-soluble crayon over dry wax oil crayon. Some water-soluble graphite pencil work completes the immediate foreground.

SKETCHING

THE VALUE OF keeping a sketchbook cannot be overstressed because visual jottings can provide a wealth of material for future drawings and paintings. Used regularly, the sketchbook becomes a reliable friend, something that you can fall back on time and again when searching for inspiration or source material. And just as important, the habit of sketching regularly will give you constant drawing practice.

Drawings made on location have a special spontaneity. Immediate reactions to things seen are very often the most important element in a drawing because they reveal what, for you, is the essence of a subject. Sketching with coloured pencils

adds an extra dimension to the experience of observing and drawing. Observation is the key activity; it is the first step to drawing well because constant observation will help you to record lines and shapes accurately. In fact, a carefully observed sketch of a subject can be a real eye-opener, very often challenging preconceived ideas about how we think things look. Try drawing a subject a number of times from different angles; this will help in the process of understanding its structure and form, thus enabling you to come to terms with it before including it in a more worked-up drawing.

Because both dry and water-soluble pencils are so easy to carry about, they are the ideal medium

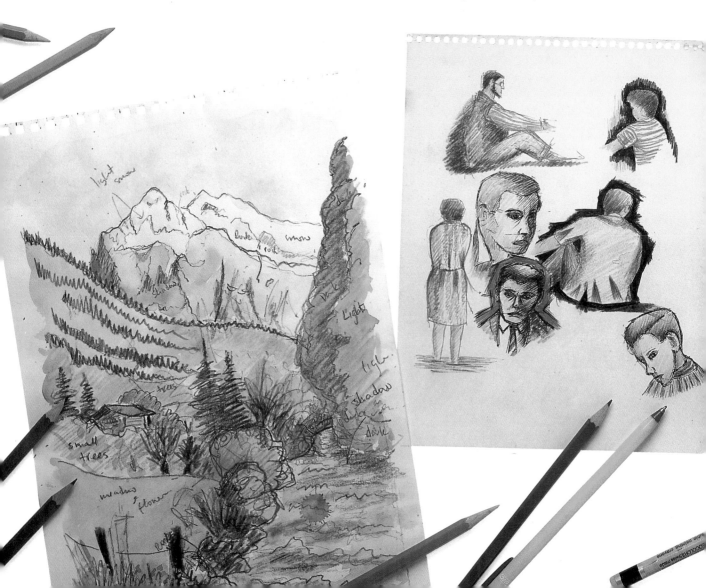

*Pages from my sketchbooks are illustrated here.
There are a variety of subjects including landscape,
figures, an old post and some 'thumb nail' sketches
of buildings and trees. The drawings are produced
with a variety of media and include water-soluble
and dry coloured pencils, coloured pencils combined
with ballpoint pen, and graphite pencil work. There
are also written notes on some of them. These
serve as a reminder of colour and shades, and are
as important as the visual sketches. I call this
process 'information gathering'.*

for colour-sketching. It means they may be taken
on holiday without fuss and without using up vital
luggage space. You can use them to record scenes
or events wherever you happen to be, and re-live
the holiday later by transforming sketches made
on location into larger-scale paintings. For the pro-
fessional illustrator, the ability to work on location
with coloured pencils is a distinct advantage, and
visuals in a sketchbook can then be taken to a client.

EXERCISE TO TRY

Draw moving subjects, because this will speed up your
ability to observe and sketch quickly. If you are
drawing people engaged in an activity, notice that they
often keep returning to the same position; this gives
you more time to observe them. Look at the subject as
much as possible rather than at your paper, and aim to
let your hand follow your eye.

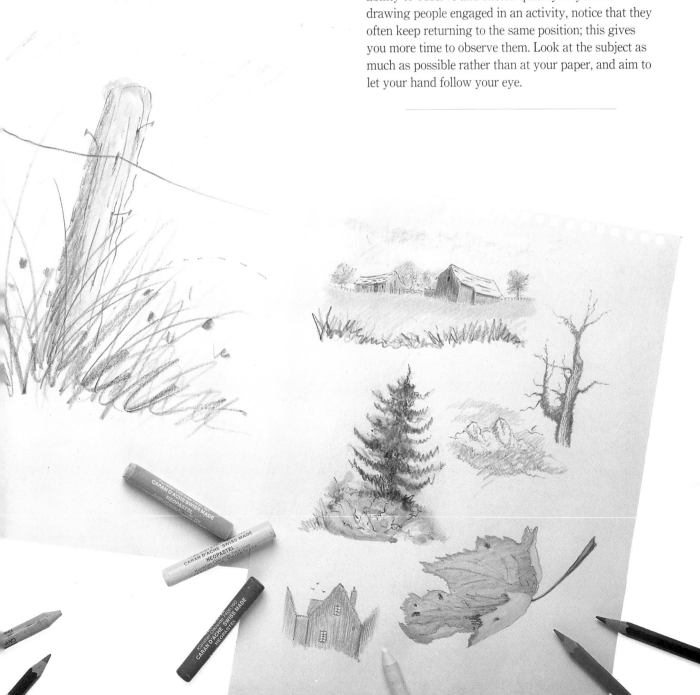

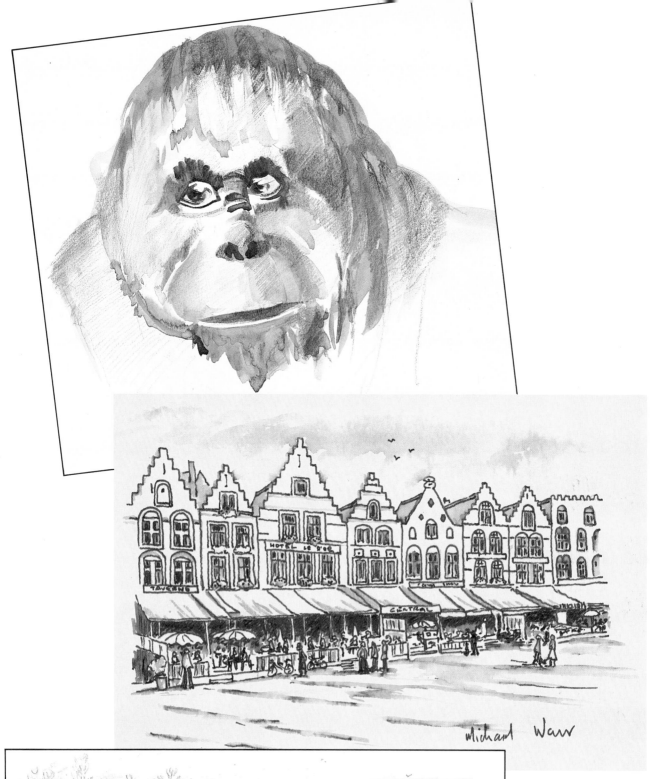

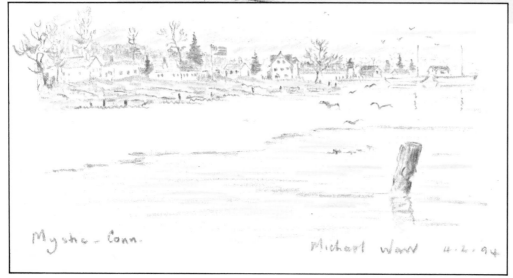

Michael Warr

Mystic - Conn. Michael Warr 4.4.94

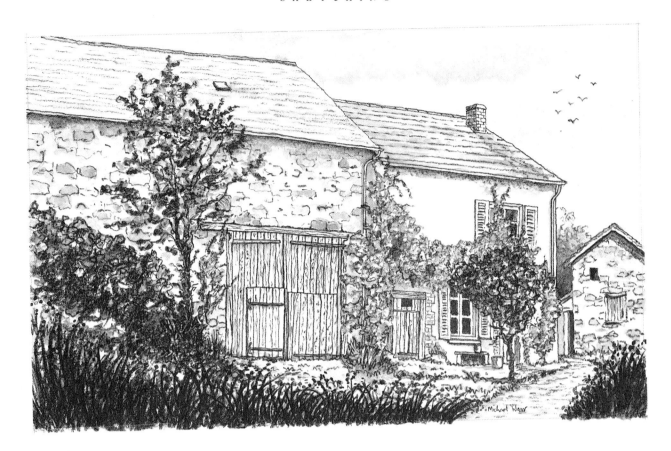

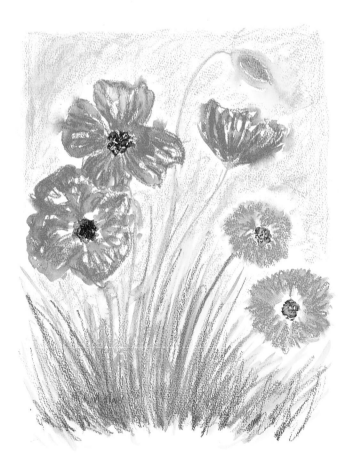

An international selection of sketches appear here. The chimp, drawn by Sylvia Whittall, was produced quickly during a visit to a zoo. Water-soluble coloured pencil is brushed over with water – some of the pencil marks remain in their dry form. A water-soluble felt tip pen captured the row of cafés in Bruges, Belgium (opposite, middle). Bottom left is a drawing made on a paper tablecloth, while I was waiting for a meal at a restaurant in Mystic, Connecticut, U.S.A. The crayons were actually provided on the table. The drawing of my home in France (above, top) is rendered entirely with water-soluble graphite pencils. Colourful poppies and cornflowers (left) were sketched in about 15 minutes with Neocolor II water-soluble crayons. The colour was applied dry and water added quickly. Speed was of the essence in order to retain spontaneity. As you can see, sketching is a wonderful way in which to capture all manner of subjects, wherever you happen to be.

ACHIEVING TEXTURE

MOST PEOPLE HAVE reacted to surface textures at some time or another, but to be able to record them with our art materials is something of a special privilege. There is a magical quality to surfaces such as knotted wood, lichen on old, decaying gate-posts, peeling plaster and corroded bricks. The secret to capturing surface textures lies in the correct choice of media and drawing surface – the rougher, hand-made watercolour papers are ideal for crumbling or eroded surfaces, whereas smooth or hot-pressed paper is better for smooth textures, such as chrome plating. Spend some time analysing the textures in a subject before embarking on a drawing: just how rough or smooth is the surface? Does it form a pattern of some sort? If so, is it regular or irregular, and what type of hues or shapes is the pattern made up of, and does it have a sense of movement or direction? Does tone play a part? What type of pencil marks can you think of that will suggest the texture? Any information of this sort conveyed in the drawing stage will show an understanding of the subject. Guard against cramming every part of a drawing with texture; allow the subject to breathe, otherwise you will not be able to see the wood for the trees!

TEXTURED DRAWING SURFACES

Very rough hand-made watercolour papers are quite suitable for texture exercises, but other surfaces, such as different types of paper and primed boards, are also well worth investigating. Woodchip wallpaper, for example, produced in varying degrees of roughness, makes an ideal ground. Interesting results can be obtained by working with Neocolor II water-soluble crayon. It is possible to add new life to a wall covered in woodchip wallpaper using this medium wet or dry.

If you are worried about the permanency of a mural, acrylic matt varnish applied over dry work will give protection for many years.

Acrylic gesso is a thick, creamy priming substance. Applied unevenly onto thick card, it will provide textures to your own requirements. The gesso dries quickly and is extremely permanent. Having an acrylic base, it is slightly flexible and will not crack. White acrylic paint from a tube can also be used to create a textured surface. Applied unevenly to a rigid support such as thick mountboard, it will work similarly to acrylic gesso.

Sandpaper provides an interesting textural surface for coloured pencils, crayons or pastels. If water-soluble versions are to be used, it is advisable to stick the sandpaper to a rigid surface, such as thick card, in order to prevent it cockling.

We cannot rely entirely on the surface to provide texture; the materials also need to be employed in a certain manner. Let us examine some combinations of surface and materials that will create textural qualities.

Alpine Texture

Pablo coloured pencil on illustration board

The collection of shades, subtle colours and textures in this alpine farm subject were irresistible. Coloured pencils are a good choice of medium to use in order to depict such delightful subject matter, as detail and line can be combined with a wonderful textural quality. And although you cannot mix colours in the same way as with paint, you have good control of shading and line. There are no great colour contrasts in this drawing, but fifteen colours were used: slate grey, grey, ochre, brown, yellow, ultramarine, light blue, black, light grey, umber, russet, sepia, cream, cobalt and violet.

Michael Warr

STONE WALL

WAX OIL CRAYON

A section of stone wall provides an excellent subject for a study of texture. In a subject such as this there are many more colours than at first there might appear to be, because the underlying colour will have become weathered, and will be modulated or overlaid by lichen and moss. A textured paper will provide an underlying sense of texture across the whole drawing, and will also cause the dissolved colour to form irregular little pools when it is moved about with the brush, which will further add to the impression of texture.

COLOURS USED

White 7000.001 · Grey 7000.005 · Black 7000.009 · Yellow 7000.010 · Natural Umber 7000.049 · Russet 7000.065 · Light Olive 7000.245 · Olive 7000.249

SURFACE

Oil sketching paper

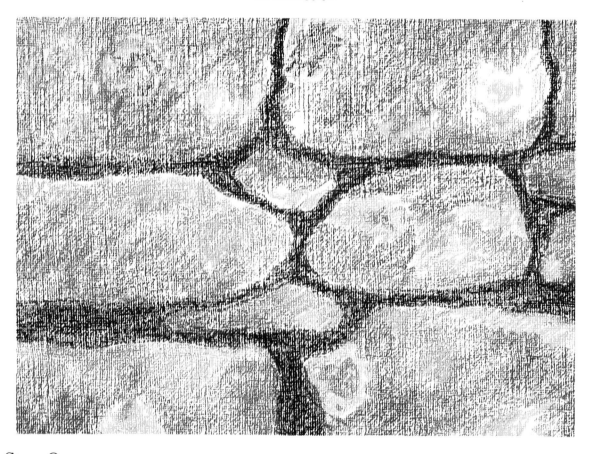

Step One The main shapes in the stone wall are drawn in as simple, fairly flat shapes. No attempt is made to draw any detail; this is achieved through the manipulation of the colour at a later stage. The structure of the wall is indicated with warmer and lighter colours – greys, umbers, and yellow for lichen – for the surfaces of the stones, and black in the recesses. Note how the surface of the oil sketching paper is helping to convey an overall feel of texture.

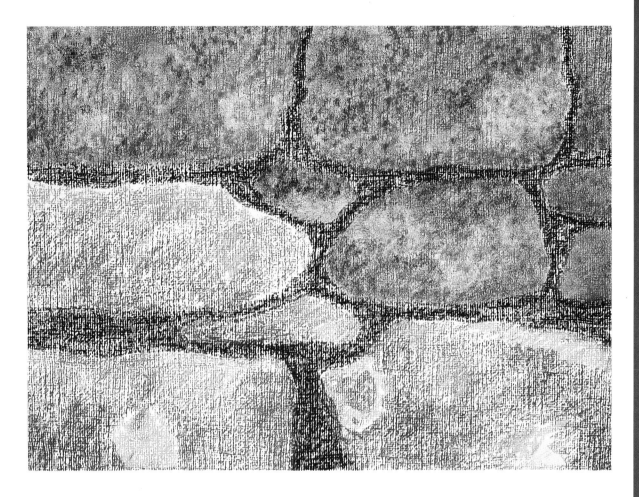

Step Two Turpentine is applied to the crayon across the surfaces of the stones using a no. 1 hog-hair brush. This type of brush has stiff bristles that can move the colour around easily. As the turpentine dissolves the crayon colour, the colour is brushed gently, with short strokes, to move it around slightly.

Be careful not to overwork it, because too much mixing on the surface of the paper can muddy the colours and spoil the effect. As the turpentine is added, note how it brings the colours to life compared to the areas that still have to be worked. Remember, colours intensify with an application of liquid.

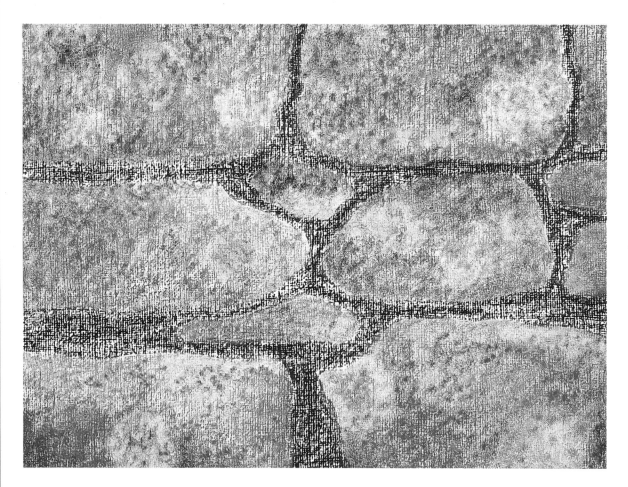

Step Three

The remaining stones are then completed in the same way. By making short, dabbing strokes you can get the colour to pool slightly on the paper to produce a pitted, weathered, textural effect. All that remains to do now is to deal with the spaces in between the stones, which will be the next stage. This action is assisted by the rough surface texture.

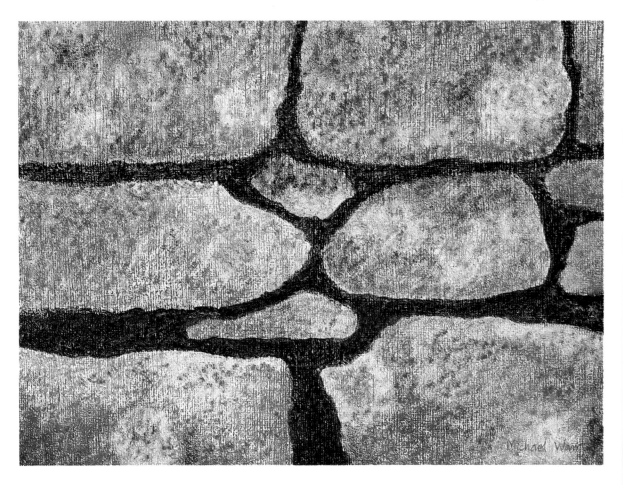

Step Four

Turpentine is applied to the dark areas between the stones which has the effect of intensifying the colour and adding definition to the stones themselves. Good contrast is created, defining the shapes of the stones more clearly. The dark pigment is not brushed too much as to do this would create lines in the colour and destroy the textural feel of the spaces.

EXERCISE

Take a selection of objects with different types of surface, such as shiny chrome, rust, tree bark, bricks, stones and fur, and find ways to capture the textures through types of pencil mark, carefully blended tonal shading, patterns of colours or tones, or whatever seems appropriate.

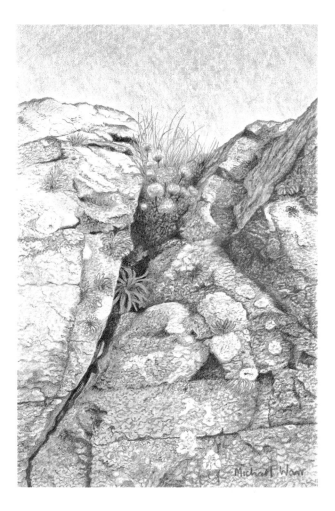

◁ *Sea Thrift*

Pablo coloured pencil on cartridge paper

Sea thrift nestles in a rock crevice, surrounded by fascinating coastal textures. By focusing on a subject in this way it is possible to observe a whole world within a small space. The subject is in an elevated position, eliminating any unwanted surroundings; all that we see is the sky, which is rendered with crosshatching in blue.

To obtain textures in the rocks, colour is stroked gently onto the surface, letting the textured paper create the initial effects. Layers of colour are worked over the top until shapes that depict the rock textures gradually emerge. It is important to let some 'accidents' dictate the general pattern of the surface as it develops.

▷ *Natural Sculpture*

Water-soluble coloured pencil on Bockingford 300gsm (140lb) paper

Texture takes many forms, and Nature provides some startling examples. The green lichen on the remains of this old tree trunk combined with the splits and large knot-hole provide an engaging subject.

Very dilute brown/grey is washed over the whole surface and allowed to dry. The drawing is then built up using water-soluble coloured pencil on the dry surface. In order to retain the finer details, a no. 1 round sable brush is used to apply water to the grain and splits. A no. 3 round sable is used to apply water to the remaining areas. The addition of water to the colours gives them the intensity and impact needed to convey the power of this natural and beautiful subject.

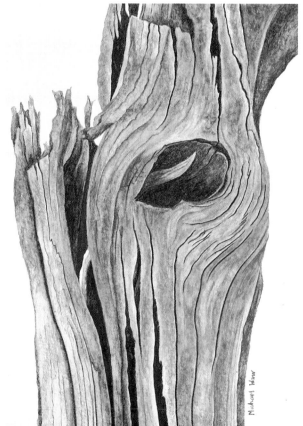

66

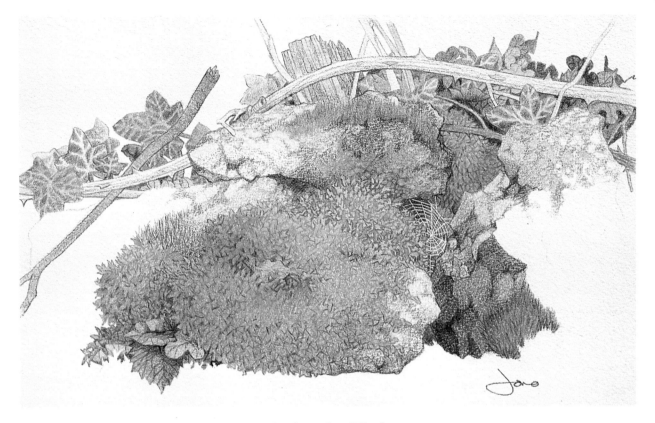

Under the Hedge

JONATHAN STEPHENSON

Dry and water-soluble coloured pencils on watercolour paper

Moss on soft, crumbling stones creates an interesting combination of textures in this composition. The fresh green and the spongy feel of the moss is captured by working dry pencil over a wash of water-soluble pencil that has been allowed to dry. This is an excellent method for providing general underlying colour on which to build up textures.

Fallen Arches

JONATHAN STEPHENSON

Pastels on tinted Ingres pastel paper

Some fallen bricks that once formed an old archway in a building prompted this interesting study of texture. The soft surface of the bricks is evident, coupled with old, soft, eroding lime mortar. Textures suitable for inspiring drawings may be found anywhere; focus your attention on the mundane, every-day objects that tend to be overlooked.

Available Austins

ANDREW SUTTON

Pablo coloured pencil on tinted Canson pastel paper

A feast of different surfaces provides many textural qualities to be captured in these nostalgic subjects. Reflective glass and chrome, honeycombed radiators, tyre treads and rusting wings are all included in this composition. The choice of paper is particularly helpful as the colour shows through the skilfully handled coloured-pencil hatching.

Australian Gum Tree

BRENDA CHAPPELL

Pablo coloured pencil on linen-grain Fabtex paper

The grain of the surface on which this composition is produced has a woven appearance and creates an unusual finish, the completed drawing resembling a fabric design. The delicate rendering of colour on a texture such as this means that the textural quality of the surface is as important to the overall effect as the shapes, forms and

colours contained within the subject. Different and unusual surfaces can lead to some very exciting discoveries of the potential of any pencil or crayon medium.

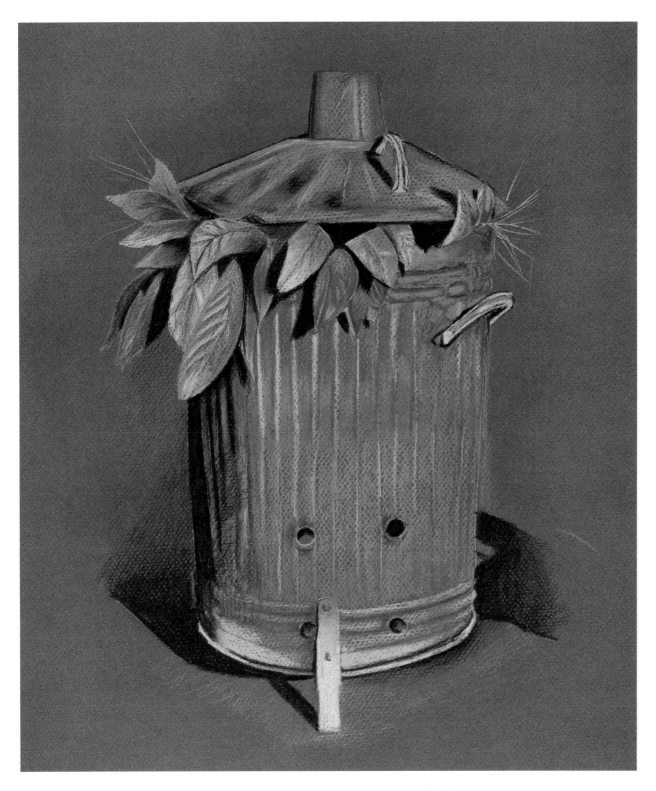

What Autumn Leaves Behind

ANDREW SUTTON

Pablo coloured pencil on tinted Canson pastel paper

Rusting metal can provide interesting textures. The appearance of the rusting metal is captured in a combination of oranges and pinks, and the ridges in the surface are described with light and dark vertical lines, which aptly convey how the ridges catch the light on one side and are in shadow on the other side. The upper part of the incinerator catches more light than the lower part. It is interesting to note that the texture and colour on the rusty part is echoed in some areas of the withered laurel leaves.

STILL LIFE AND FLOWERS

FLOWERS AND STILL-LIFE objects are subjects over which you have control in the sense that you can arrange them to suit your own tastes and ideas. Flowers lend themselves particularly well to coloured-pencil work; their vibrant colours can be captured with a range of pencils either on location or indoors. Depending on their availability, garden and wild flowers are suitable subjects, although be careful not to take protected species back to the studio. Flowers of all types often feature as a part of still-life groups, and for this reason they are included in this section.

Any objects can be grouped together in order to create a still-life composition. The choice can be random, consisting of unrelated objects chosen simply because they appeal, or they can be linked by a particular theme. The group can consist of man-made things only, or it can be a combination of natural and manufactured ones. Whatever you decide, it is worth spending time arranging the set-up. Aim to create an interesting overall shape, and also look for good shapes between the subjects you are using and their shadows that link one to another.

OBSERVATION

Drawing flowers and objects is an excellent way to improve your powers of observation; it also provides a good opportunity to try a number of different coloured-pencil techniques. These may range from using only two or three colours, drawing with water-soluble pencils and dissolving them with water to create a watercolour effect, working on textured surfaces, to working with every colour in the box.

The study of flowers also enables you to really discover what is possible with coloured pencils as far as colour matching goes. Close proximity to the subject enables direct colour comparisons to be made, and colours can be reproduced accurately if desired. This type of exercise helps you to discover the colour potential of your set of pencils, and to see if you need to extend the range. Bright, intense colours are normally required to capture the cheerful hues of flowers. Their stems and leaves usually consist of a number of greens. Look carefully at these and choose your pencils accordingly; there is a wonderful selection of ready-made greens available.

ARTISTS' TIP

Keep your early flower and still-life compositions very simple – just three or four objects – and place them in front of a plain background.

Fantasy Flowers

Water-soluble crayons on Waterford 600gsm (300lb) paper

This imaginary composition is based on the sheer joy of seeing how colours behave when they are applied to a damp surface.

First of all the paper is heavily dampened using a 2in flat brush loaded with clean water – hence the choice of a heavyweight watercolour paper with a reasonable tooth. Colour is then transferred from a paper palette using a no. 20 round Dalon brush. As the colour comes in contact with the very damp surface, it disperses, creating natural shapes.

Because the surface remains very damp, it is possible to draw into the picture with crayons as the shapes evolve. Again, as the water-soluble crayon makes contact with the surface, the colour will diffuse immediately. This enables the work to remain in a fluid state throughout. It is important, when creating this type of composition, to complete the work before any of the areas dry in order to ensure continuity and unity throughout the picture.

'Fantasy Flowers' Michael Waw

WITH A TWIST

PABLO COLOURED PENCIL

When setting up a still life, arrange the different items so that they overlap each other; try to avoid ending up with a string of unconnected objects. Arrange them into an interesting and balanced overall shape, such as a triangle or L-shape. And remember that the shadows cast by the objects are an important part of the composition: they can create a strong pattern that complements the objects, or they can be used to unify the composition.

By using coloured pencils on smooth board it is possible to achieve very smooth, gradual, almost photographic blending between tones and subjects; this technique is particularly appropriate here for describing the bottle, which is featured in this demonstration.

COLOURS USED

Grey 666.005 · Yellow 666.010 · Sanguine 666.065 · Carmine 666.080 · Prussian Blue 666.159 · Malachite Green 666.180 · Dark Green 666.229 · Lemon Yellow 666.240

SURFACE

Illustration board

Step One The bottle and lemon are lightly drawn to establish their shapes. They are treated as one overall shape at this stage, with minimal differentiation between the two. Some crosshatching of greys and blues provides a light, high-key background that defines the shape of the bottle and the back edge of the table-top. A little colour is applied to the lemon and to the shadow that it is casting on the table in order to ground it and establish the plane of the table-top.

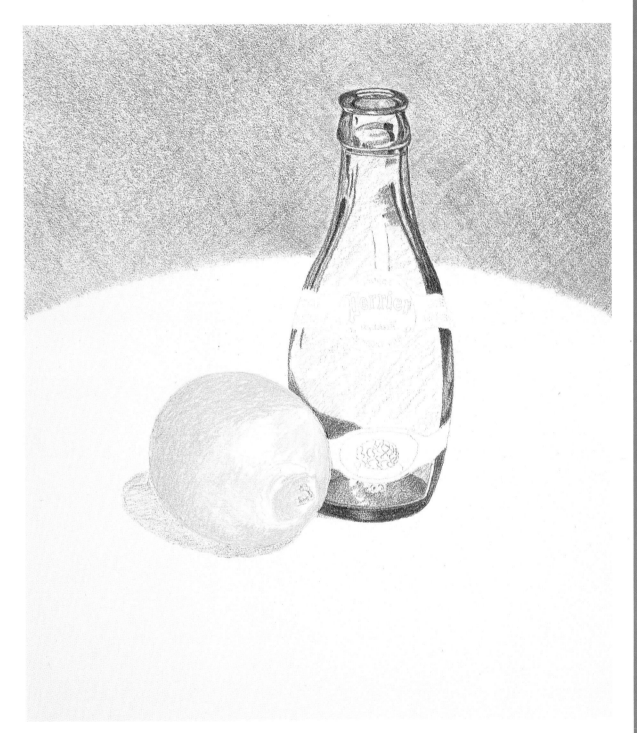

Step Two Drawing on the bottle begins in earnest; reflections and shadows are introduced using malachite (a blue-green) and a dark green. The final colour is achieved by crosshatching one over the other. A bright yellow is crosshatched over lemon yellow in order to define the lemon. Note that at this stage the white surface of the board is retained where highlights will appear. This action will ensure a bright, crisp white, rather than highlighting with a white pencil.

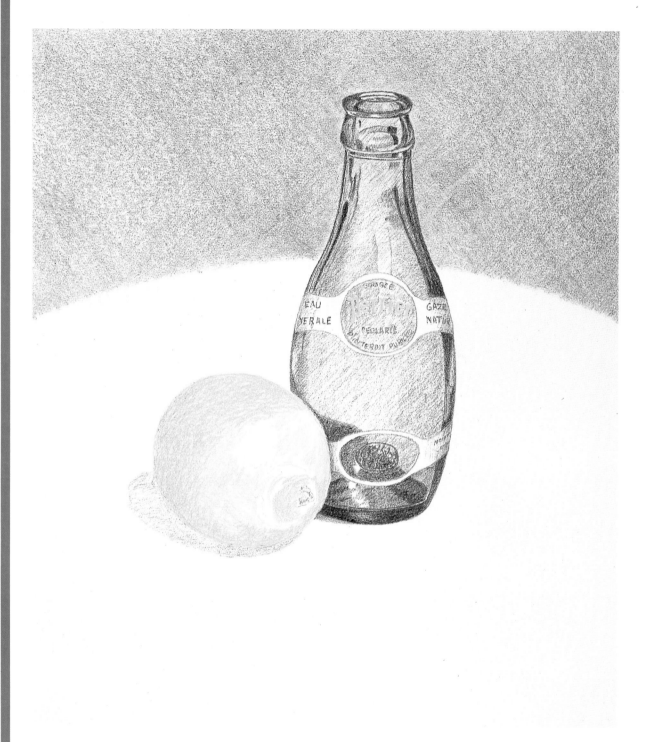

Step Three Work continues on the bottle; a little more crosshatching with the two greens describes the background that can be seen through the bottle. The labels are defined with some medium grey shading, and the lettering is added with bright yellow for the product name and red for the symbol at the base. Time spent in this area is always necessary as a simple composition calls for some interesting aspects on which to focus and therefore create pictorial interest. These details complete the bottle; we are now ready to continue with the lemon and shadows.

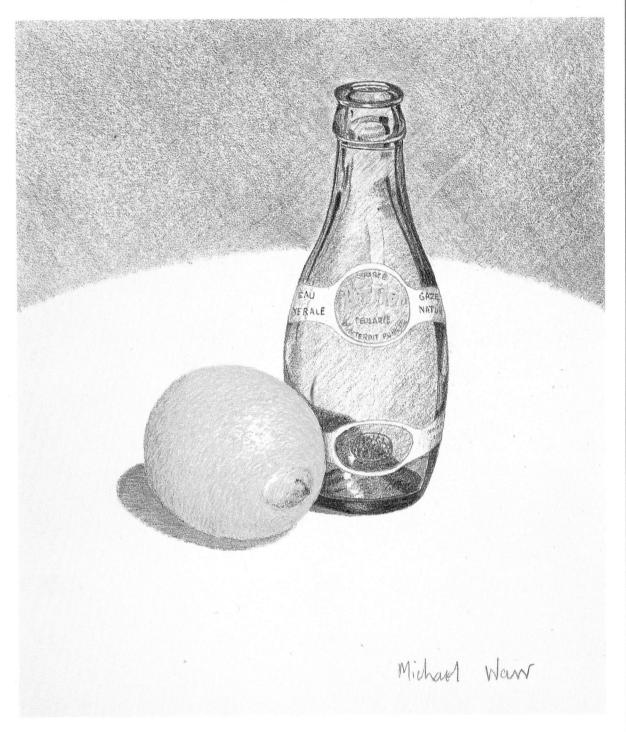

Step Four More yellow is added to the lemon and some grey shading is introduced on the left. Note how the highlight is still retained at this stage by using the white paper surface and allowing it to show through. Crosshatched greys are used to depict the lemon's shadow, completing this simple but effective drawing. The white café table on which the objects sit is simply the white illustration board and does not require any more shading or colour. Try producing simple still-life studies by using just two objects and uncomplicated surroundings – often drawing less says much more!

Monet's Waterlily

Water-soluble crayon on Bockingford 300gsm (140lb) paper

This waterlily was captured in Monet's garden at Giverny, France. Water-soluble crayon provides the rich colour, particularly for the dark leaves that act as a foil for the more delicate colours of the petals. In a detailed subject such as this, block in the lighter petals first, followed by the darker leaves, because strong, dark colour can be used to sharpen and define the edges of the light petals. A fine sable brush is used to tease out darker colour from the ends of each petal in order to depict the veins.

Statue and Vine

Pablo coloured pencil on illustration board

All the vertical elements combine to create an interesting composition. The green leaves of the vine contrast well with the grey statue, creating a 'hide-and-seek' effect. Gardens are ideal places in which to find drawing subjects: you do not need to *transport your equipment far, and it is possible to complete all the work on location. This drawing was produced on illustration board with approximately twelve colours – a dark background adds impact to the statue.*

77

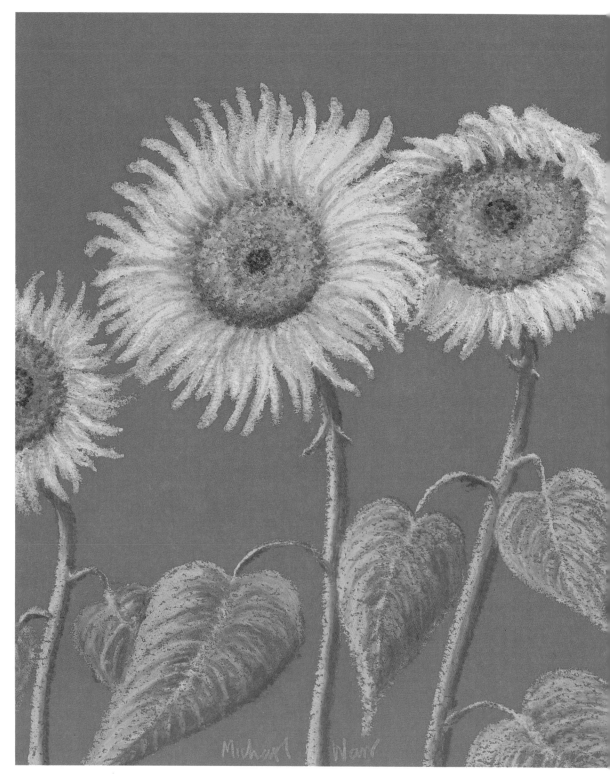

The Providers

Neopastel on coloured Canford paper

Sunflowers produce seeds that are put to many uses. Here, the golden flowerheads are set against an azure sky, provided by blue paper. The opaque quality of pastels enables them to cover virtually all paper colours, a distinct advantage in this case where the paper colour is retained in order to provide a clear blue sky.

Two yellows – light yellow and a darker, strong

yellow – are used for the petals, with a little ochre for the shading. Ochre, brown and light green form the seed centres. Note how these colours are varied in each of the centres to provide extra interest. Attention to details such as these improves the overall effect of the completed work.

The stems and leaves are depicted with light, dark and medium greens. The blue paper peeps through here and there, creating some texture on the leaves. This is a useful technique which works well with pastel painting. The broken surface colour becomes an integral part of the composition. An extra dimension can be explored, which is already there for the taking!

Sardines, Limes and Cockles

SYLVIA WHITTALL

Water-soluble coloured pencils on watercolour paper

The delicate colours of the fish and the newspaper blend together well. Only a little water is added to the pigment here and there, to create the subtle colours of the subject. The area surrounding the newspaper is left completely dry, relying on the texture of the watercolour paper and its colour for a suggestion of a background.

▷ ## Australian Flowers

BRENDA CHAPPELL

Pablo coloured pencils on Fabtex paper (smooth side)

Light hatching techniques are employed to depict an arrangement of Australian flowers. The light shadows are extremely attractive, providing a foil for the colourful flowers and leaves. The white of the paper is carefully retained in order to provide the petals of the white flowers, which require some shading in places. Hatching with light blue creates a subtle but interesting background. Sometimes just a little light shading will suffice to place a subject in its setting.

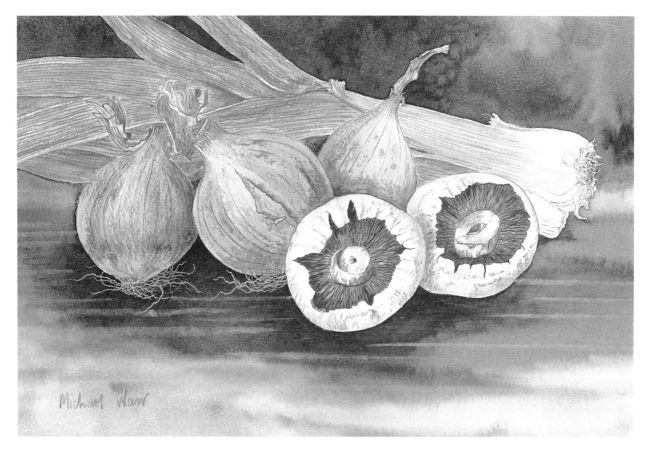

Cook's Delight

Water-soluble coloured pencil on 600gsm (300lb) Waterford
watercolour paper

*A selection of vegetables provides an interesting
composition with a mixture of colours, shapes and
textures. The shapes are blocked in with dry colour.
When the drawing is complete, the colours are
blended using water to create the roundness of the
vegetables. A no. 8 round sable brush is used for
the larger areas and a no. 1 for the details. Some
grain produced by the pencils has been retained
here and there, creating texture, particularly on the
onion skins. Dark colour in the background and on
the workbench was introduced by transferring
pencil colour from a paper palette with a no. 16
round sable brush onto the drawing. Finally, veins
inside the mushrooms were re-defined using dry,
dark brown pencil lines.*

Poppy

◁

Water-soluble coloured pencil on Bockingford 300gsm (140lb)
watercolour paper

*A simple approach is a good way to start drawing
flowers. Because of their complexity and detail,
there is a tendency for the beginner to avoid them
as subject matter. Look for simple shapes and
bright colours – record them with the minimum
amount of detail to begin with. As confidence
grows, move on to more complex petal formations.
As with any other subject, practise is the key!*

Peppers 'n Pastels

Neopastel on coloured card

*The combination of peppers and Caran d'Ache
pastels is unusual, but it provides colourful subject
matter. Lightly applied pastel does not produce
solid, flat areas of colour, but will always allow
specks of the paper colour to show through. This
enables the surface colour to become an integral
part of the composition, creating the interesting
textures that are associated with pastel painting.*

*A warm, yellow ochre paper that will blend with
the warm colours of the subjects is chosen. The blue
pastel provides contrast by virtue of its 'cool' colour.
Very light highlights are depicted with white, and
some of these are blended by light rubbing with a
finger. This technique helps to convey the shiny
surfaces of both peppers and pastels. There is very
little detail in the background and suggested
surface; all the attention is concentrated within the
main subjects of the picture.*

ANIMALS, BIRDS AND INSECTS

ANIMALS, BIRDS AND insects with their multitude of textures, colours, shapes and forms – whether pets, domestic or farm animals, or those in zoos – offer a wealth of colour-pencil drawing subjects. If you are worried about drawing subjects that move a lot, try capturing them when they are resting or asleep; at least this way you do not have to cope with depicting them in movement.

If you have pets, keep the sketchbook handy. However crude your first efforts may appear, remember practice makes perfect! The advantage of using coloured pencils for recording sketches and drawings of pets is that you have instant colour, and because you can observe them every day, colour matching becomes relatively easy. If it is possible to keep an ongoing sketchbook, you could compile a record of the growth and progress of your pets.

For people living in a town or city, access to farm animals is more difficult than for those living in the country, but there are opportunities for city-dwellers to draw farm animals during day trips or holidays. For country-dwellers, subjects are all around on neighbouring farms, but remember to obtain permission to walk across private land. Most farmers will cooperate if you promise to close all gates behind you, not to leave litter and not to cause damage to land, fences or farm buildings. There are also many specialist country parks that rear and keep farm animals; and some of these have a good selection of rare breeds.

EXERCISE TO TRY

Make a study of your pet, favourite animal, bird or insect. First practise by using one colour only. As your confidence builds, move on to a multi-coloured drawing.

BIRDS

Birds make beautiful subjects; their plumage comes in a multitude of shapes and colours. They can be observed in the garden from the comfort of a living room or out in the open. In some areas of the countryside there are hides for watching birds, usually maintained by bird clubs or protection societies, although you may need to be a member of the appropriate society in order to use them.

Some species are very colourful, while others contain more subdued hues, so it is important to have a comprehensive range of coloured pencils available from bright yellows and reds through to dark blues, black and dark browns.

INSECTS

Insects may not at first be obvious subjects to draw, but they have many advantages. They are normally small, providing an ideal study on a modest scale, so you can practise drawing detail yet still obtain satisfactory results quite quickly. A wide range of colours can be employed in relatively small areas, keeping the exercise an economical one. The most colourful insects provide exciting colour combinations contained within a small area. For example, the velvety appearance of coloured-pencil work lends itself well to conveying the finish on butterflies and moths. For those who do not feel confident about painting, the more colourful, exotic butterflies can provide inspiration and rich material for coloured drawings; some may even be applied directly onto your wall, since coloured pencils, both dry and water-soluble versions, can be put to interesting use in the art of interior design. Many insects may thus find their way onto your ceilings, walls and furniture. With this in mind, it is a good idea to protect your wall and furniture drawings by spraying them with Caran D'Ache fixative or lightly brushing them over with a matt or gloss varnish.

On 'The Alm'

Coloured pencil on illustration board

During the summer months, cattle in the alpine regions of Switzerland are taken high into the mountains in order to graze 'The Alm', while hay-making is carried out in the valley below.

This cow grazes contentedly on a mixture of grass and a profusion of alpine flowers. The sky is crosshatched with cream followed by golden ochre, colours that echo those in the main subject, and this treatment creates a more harmonious overall effect than can be produced with a contrasting sky. Cream, ochre, red-brown and dark brown provide the main colours for the cow. Light and dark greens appear in the grass, and dots of colour depict some alpine flowers; these add interest and help to give the picture a lift. This is a useful foreground technique well worth remembering.

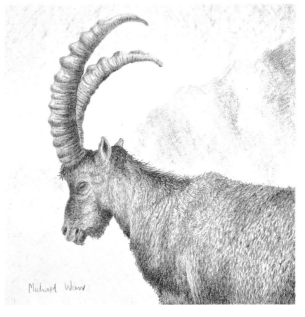

Ibex

Pablo coloured pencil on heavy cartridge paper

An ibex found in the French Alps makes an excellent animal portrait. The magnificent horns create an interesting pictorial feature; they contrast well against a delicately rendered sky and mountains.

CHEEKY PARROT

WATER-SOLUBLE PENCIL

Water-soluble pencils are particularly appropriate for this type of subject with its bright colours and strong textures, because the addition of water to the colours will intensify them. The medium also allows for a combination of drawing and painting, which will describe the varying textures of the parrot's feathers and its smooth beak most expressively.

COLOURS USED

Grey 3888.005 · Black 3888.009 · Yellow 3888.010 · Ochre 3888.035 · Prussian Blue 3888.159 · Light Blue 3888.161 · Emerald Green 3888.210 · Light Olive 3888.245

SURFACE

300gsm (140lb) Bockingford watercolour paper

Step One The outlines of the main shapes in the parrot are applied in the appropriate colours for the drawing. Simple shapes are created to begin with: if the lines are too prominent at a later stage, they can easily be slightly dissolved with water to soften their impact.

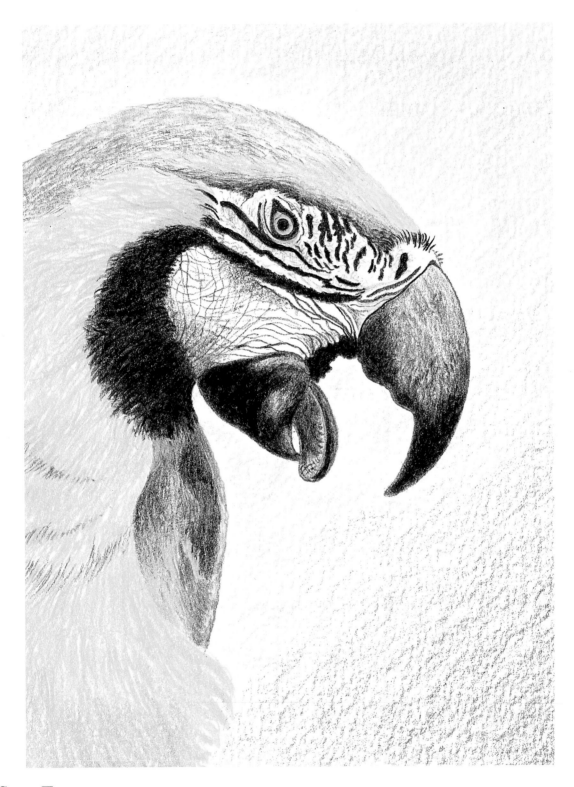

Step Two The shapes are filled in with colour using short, hatched lines for the feathers and smoother shading for the less textured areas. This attention to texture and direction will be of great importance when the water is added. Black and dark blue are applied intensely to the beak area and the plumage around the neck to provide the basis for dark colour in these areas.

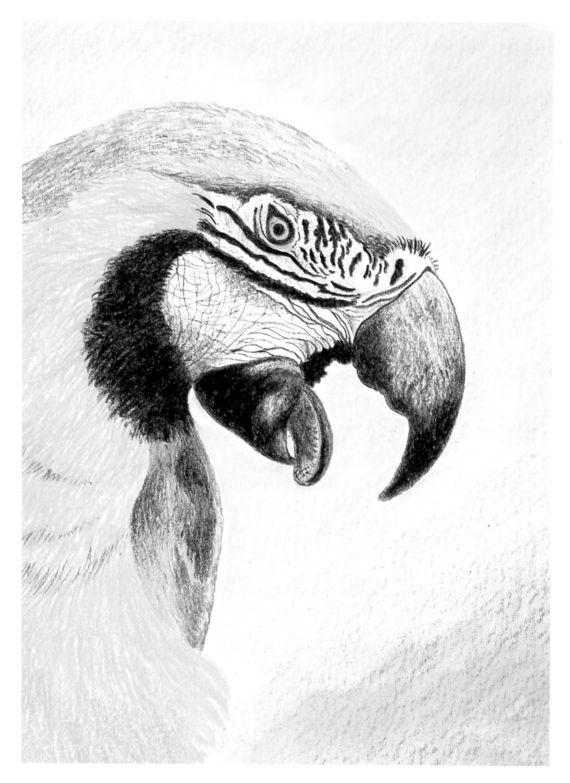

Step Three
Water is applied to the background pigment using a no. 12 round Dalon brush, and the colour is blended slightly to soften it. However, some of the pencil marks that have been applied are retained, providing good textural quality to the background of the illustration.

The background colour remains light, ensuring that it does not detract from the main subject. Sometimes backgrounds become overpowering, causing areas in a drawing to become confused and undefined. Clarity of the plumage and beak is important in this case.

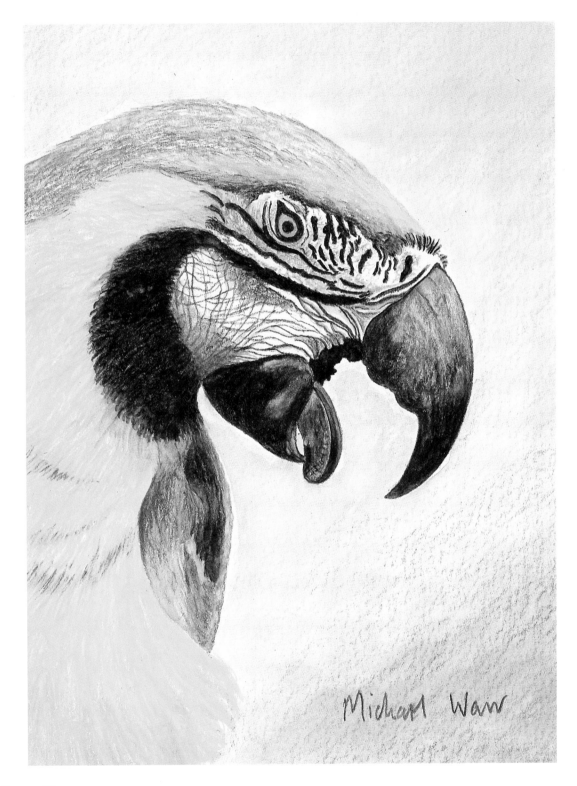

Michael Waw

Step Four

When the background is dry, water is applied to the parrot using a no. 3 round sable brush. Each area of the illustration is treated separately in order to maintain detail and definition, and each is allowed to dry before the neighbouring areas are blended so that colours don't run into each other. Work the pigment gently with the brush until you have an area of colour that is solid but not completely dense and even. The colours take on extra life as soon as the water is added; note how the colours intensify and glow which is a sign of good quality pigment.

The Gypsy in My Soul

Coloured pencil on illustration board

This dappled-grey gypsy pony provided a wonderful challenge. The pattern on the pony's coat is produced by applying darker colours, and then burnishing lighter colour over the top. The underlying colour merges into the surface, rather than appearing to sit on it. Burnishing is a good way to diffuse any surface pattern or texture as it produces a more natural appearance.

Swallowtail

Pablo coloured pencil on illustration board

Swallowtail butterflies are now extinct in Britain, but in the Swiss Alps they are to be found in abundance, and this drawing is a tribute to them. Note that butterflies are not exactly symmetrical. The left-hand side of this specimen is broader than the right. First, establish the overall dimensions of the butterfly, then lightly sketch in the main shapes of the wing pattern. Then develop the colours with light hatching strokes.

Grasshopper and Moth

Pablo coloured pencil on heavyweight cartridge paper

These two insect subjects were found in an alpine village. Even when the surrounding scenery is magnificent, there is always time to focus on small details. A range of green pencils is used to convey the grasshopper's beautiful colours. The moth provided an excellent study in colour and contrast. The colours used are light blue, dark blue, black and reds with a touch of yellow.

Kingfisher

Water-soluble coloured pencil on Bockingford 300gsm (140lb) watercolour paper

Bright colour is required to convey the brilliant foliage of a kingfisher. This bird's appearances are generally rather fleeting so the subject must be captured quickly. This study was produced in well under an hour.

The subject is drawn with water-soluble pencil onto dry paper. A no. 3 round sable brush is then loaded with clean water and brushed over each area to activate and intensify the colours. Note how areas of white paper are retained in order to keep the subject alive. If this technique is applied in a random way, it will work more naturally than if white areas are retained by design.

LANDSCAPES AND TOWNSCAPES

THESE TWO INTERRELATED subjects are probably the most popular for drawing and painting. A love of landscape appears to be inherent within most people, and it offers many possibilities for experimenting with different media and trying various ways of conveying the sense of place. As subject matter, landscapes and townscapes are instantly available throughout the year, either by working outdoors or from the comfort of our own homes.

Coloured pencils, both dry and water-soluble, pastel, water-soluble crayons, wax oil crayons and water-soluble graphite pencils, are all excellent for producing landscapes, as all can be employed in a broad sweeping manner as well as in a very detailed and precise way, or in a combination of the two approaches.

Landscape, and the elements contained within it, allows for a variety of approaches in the use of colour. You can make a drawing using just two colours or 102; the choice is yours. Hues may vary from subdued to very bright, depending on the time of day, the weather and the effects of the light; this is what makes landscape work so exciting. It provides constant inspiration, a continuing challenge to our thoughts and ideas. A sketchbook and coloured pencils are ideal for recording the atmospheric effects and changing seasons that make landscape such an interesting subject. Whenever the opportunity arises, sketch the elements – such as trees, water, crops, fences and gates, and skies – that make up a landscape.

The English landscape painter, John Constable (1776–1837), claimed to produce a study of the sky every day. Strong discipline indeed, but the observation and recording of different effects in the sky is a very useful exercise, even if you can only manage a few sketches at different times of the year. Clear blue skies in particular are worth practising with dry coloured pencils, as they can be difficult to achieve. Gentle crosshatching with two or three shades of blue seems to work well, and evenness of colour application is the secret.

SEASCAPES

Those who live in coastal regions have easy access to seascapes. Atmospheric studies play a large part in the evocation of seascapes, and pencils and crayons are quite capable of coping with such subjects if they are employed in a creative manner. Apart from the natural elements that make up a sea picture, boats and coastal buildings are also important features needing careful observation. Draw these whenever possible and include them in your compositions. Water-soluble pencils and crayons lend themselves particularly well to seascape work, because the effect when water is added conveys the flow of water and waves perfectly. Large expanses of sky are often visible over the sea, and again water-soluble pencils and crayons will help you to express the effects of skies influenced by large areas of water. Keep an open mind and experiment by mixing the media.

TOWNSCAPES

The term 'townscape' can be confusing. Is it a landscape with buildings in it, or a view of a town? Accepted townscape pictures are more likely to contain mainly buildings and people set in a city centre or urban environment.

Coloured pencils and crayons are extremely good for townscape work as the precision they make possible means that architecture can be depicted most effectively. Subjects such as buildings demand a reasonable degree of accuracy in their depiction, and some knowledge of linear perspective is useful. Linear perspective is the phenomenon whereby parallel lines – such as those formed by the sides of buildings – that extend away from you appear to converge, and which if continued would meet on the horizon. The horizon coincides with your eye level – a useful fact if you cannot actually see it. Linear perspective can be used to make objects drawn on a flat surface look three-dimensional, and will also help you to keep features such as buildings which occur in different parts of the scene in the correct scale within the composition as a whole.

Ways of conveying towns and cities in pictures vary considerably; some will include figures, others not; cars may be seen on the streets, either moving or parked; towns may be sunlit or contain rainy elements, and sometimes the artist will choose to depict evening, complete with artificial light from streetlamps and shop windows. The permutations are endless.

City Reflections

Pablo coloured pencil on heavyweight cartridge paper

A drawing based on the Manhattan skyline provides an opportunity to explore a group of buildings lit from within as well as being bathed in the light of the setting sun. Even a city such as New York appears dwarfed by Nature when its backcloth is a dramatic evening sky.

Colours in the sky are applied horizontally, and the yellow is continued down behind the buildings. The same yellow more strongly applied is used for the lit widows. Once the sky is complete, the outlines of the buildings are drawn in. Yellow is applied in horizontal strips across the building shapes, and finally the dark colour is introduced. The colours reflected in the water are mixtures of those in the sky and buildings, and include: slate grey, carmine, yellow, violet, lilac, vermilion, sepia and finally, Prussian blue.

LAKE IN THE MOUNTAINS

COLOURED PENCIL AND PASTEL

Coloured pencil and pastel can be combined to produce drawn shapes and detail, with larger areas of colour blocked in on texture paper, giving the drawing an interesting overall surface.

When selecting a landscape composition, concentrate on one centre of interest and don't try to include too much. If you find it difficult to choose an area, use a viewfinder – a rectangle cut from the centre of a piece of card – to isolate one section at a time until you have a pleasing composition. Also, don't be afraid to move things about if it will improve the picture. Features such as trees and boats should be grouped together, rather than strung out across the scene. You can also heighten or shorten features, or leave them out altogether if necessary.

COLOURS USED

Black 666.009 · White 7400.001 · Flame Red 7400.050 · Brown 7400.059 · Scarlet 7400.070

SURFACE

Tinted Canford paper

Step One The main shapes of the mountains are drawn in with black pencil. No attempt is made to include any indication of colour or tone, or any detail, at this stage. The shapes themselves overlap and interlock to create a quite varied but unified composition.

Step Two Brown pastel is introduced into the outlined mountains in the shadow areas. The shading follows the drawn shapes but varies in intensity within each one in order to keep the differentiation between them and to provide a suggestion of form. All the shading is done lightly enough to let some of the original paper colour show through and to provide interest and texture. The shading is kept very simple and left unblended, as simplicity is the keynote of the piece.

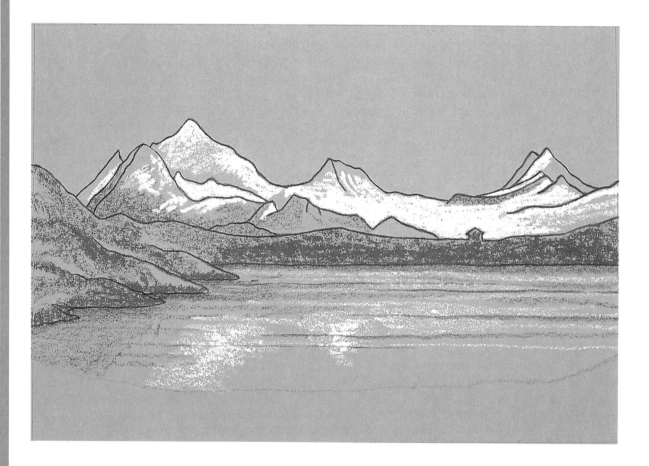

Step Three
Snow is introduced into the mountains with white pastel, following the shapes provided by the black pencil line. Reflections in the lake are created by using lightly applied white and brown pastel plus some black pencil lines. Some mountain shapes are left untouched at this stage to continue the differentiation between shapes – the eye moves from shaded area to almost plain paper, to white – in order to retain the sense of distance. Again, simplicity remains the key here.

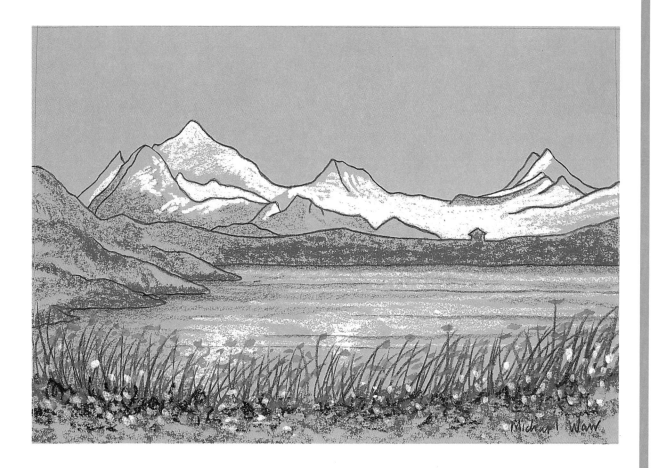

Step Four

Brown pastel shading across the foreground introduces texture and solidity in this area, and the flowers and grasses are drawn in over this. Stems and grasses are introduced with a black pencil and black pastel, while the flowers are put in quickly with dashes of reds and red/oranges. The splashes of colour provide the picture with some zest – an ingredient which adds life to the composition.

EXERCISE TO TRY

Take a place you know well and have easy access to – it could be a landscape, or the street outside your house, or even a part of your garden – and make a series of sketches of it at different times of day, over a period of time. Study in particular the strength and quality of the light – whether it is bright or dull, warm or cool, whether it has a particular colour cast visible in the highlights and shadows – and use this, together with seasonal indicators such as foliage, to convey a sense of time and season.

Yellow Landscape

Water-soluble crayon on Bockingford watercolour paper

A field of rape seed provides a wonderful splash of colour when it is in full flower, and in a setting such as this leads to a composition comprising blocks of strong, basic colours: blue sky, yellow field, green stems, brown earth.

The crayon colours are applied dry onto a dry surface, and when the drawing is complete, water is added with a no. 18 round sable to dilute the colours but not blend them. A summer blue forms the sky, while a strong and a medium yellow create the bright haze of the rape seed. Olive green is used for the stems and grasses. A red-brown, a darker brown and some touches of dark blue provide the immediate foreground colours.

▷ Misty Evening

Coloured pencil on watercolour paper

A misty effect is created by adding water to Supracolor Soft coloured-pencil work. The bands of colour have been diluted lightly so that some of the pencil grain is retained, producing textural qualities in parts of the study. The colours are allowed to merge slightly but have not been blended. Areas of white paper are retained, giving the work a little 'breathing' space and instilling it with life and verve. Be careful not to over-design these light 'chinks' as they can easily look contrived, taking away the natural feel in the work.

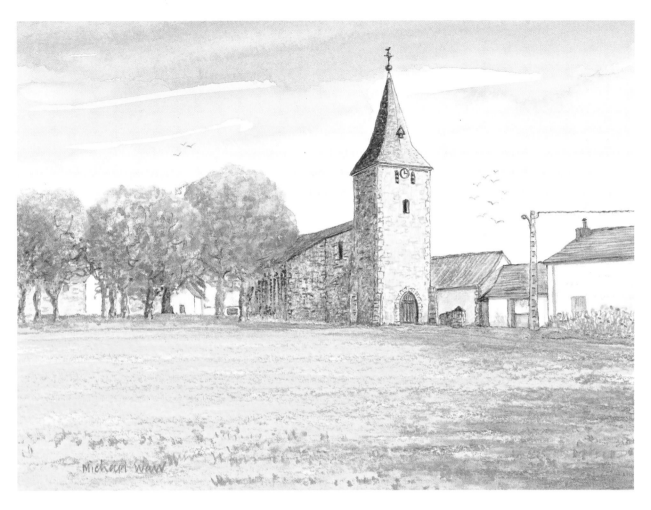

△ L'Eglise, St Dizier-Leyrenne, France

Water-soluble coloured pencil on 300gsm (140lb) Bockingford
watercolour paper

*Two methods of applying water-soluble pencils
have been combined in this drawing. The sky is
painted with colour from light and medium blue
pencils that have been applied to a paper palette
and diluted with water. The rest of the picture is
produced by adding clean water to drawn lines and
shading. Evidence of shading can be seen in the
large green area of foreground, in the form of
pencil grain. The resulting texture helps to suggest
grass and some shadow.*

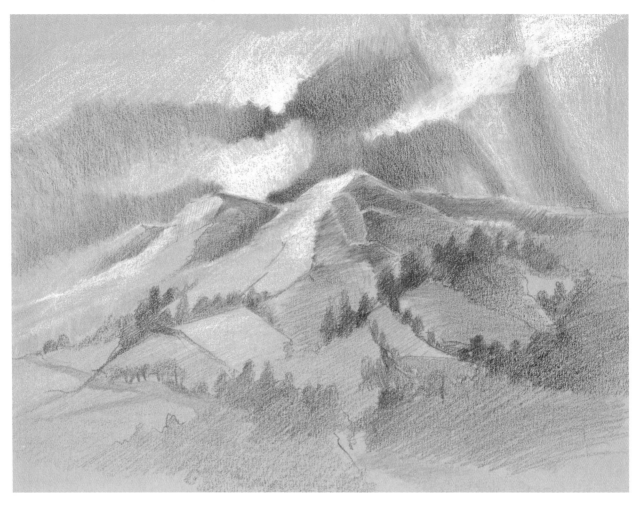

Cumbria 94

SYLVIA WHITTALL

Pablo coloured pencil on grey pastel paper

A loose drawing of Cumbrian mountains produces a dramatic effect despite gentle handling of colour. There is a good example of counterchange where dark clouds appear behind light mountains and light clouds appear against dark mountains. The light application of colour in the foreground enables the eye to sweep up to the mountain tops and the interesting cloud formations beyond. The use of white pencil works very well because a medium-grey coloured surface was selected.

▷ ## Along the Murray River

BRENDA CHAPPELL

Pablo coloured pencil on Ingres pastel paper

Australian gum trees make a good subject on blue/grey paper because the paper can be utilised for the trunks and branches, which are bleached almost white by constant sunlight. A little white here and there heightens this effect. Purple, mauve and blues create shading and cast shadows. Note how the root formations are delicately hatched, disappearing gently into the ground at the base of the picture.

- chappell -

Winter, Central Park, New York

Wax oil crayon on Waterford 600gsm (300lb) paper

Although wax crayons generally work best on oil sketching paper, here they are combined with diluted water-soluble crayon, so watercolour paper is used.

The trees and foreground vegetation, including the snow-covered area, are drawn onto dry paper. A patch of purple-blue water-soluble crayon is diluted with water on a paper palette and applied as a wash over the whole drawing. Because the wax crayon areas act as a resist to a water-based medium, the wash settles only in the areas that are not covered with drawn shapes. Finally, some water-soluble crayon and wax crayon diluted with turpentine are spattered and flicked into the immediate foreground to create textures with oil and water-based media.

▷ February Skyline, New York

Pablo coloured pencils on heavyweight cartridge paper

Snow in Central Park provides an interesting contrast to the skyscrapers above. Lightly shaded cool greys and a warmer orange-yellow create the early morning light against which the buildings are seen clearly. The buildings, which are a mixture of styles from Art Deco buildings of the 1920s and 30s to modern concrete-and-glass constructions, are depicted in browns and greys. There are only two layers of colour at most on the buildings; being distant, they do not require very much detail. The shadows in the snow-covered foreground are depicted with light grey and ultramarine; a mixture of slate grey and sepia is used for the exposed parts of the large rocks. About half the drawing consists of white paper, which adds to the drama and contrast contained within the subject matter.

Michael Warr

The Jungfrau ▷ Ploughed Field

Coloured pencil on illustration board

Water-soluble crayon on watercolour paper

An intentional gap is provided in this composition so that the eye can travel through to the marvellous mountain beyond. Two important subjects in the middle ground flank the main mountain, helping to focus attention there. On the left is a group of pine trees and on the right, two dead pine trees, a reminder that life in the Alps is beautiful, but very harsh at times. These two skeletal trees form strong, almost silhouetted shapes against a clear blue sky, which is created by crosshatching two blues, one slightly darker than the other. The strong light on the rocks provides good contrast with the darker green pine trees behind. Shadow on the rocks contrasts with lighter green grasses and alpine flowers in the foreground, creating classic counterchange: dark against light and light against dark.

This corner of a sunlit ploughed field, full of vibrant colour, is depicted by first drawing the scene with broad, loose blocks of colour in quite a sketchy way onto dry paper. A brush is loaded with water and is used to apply water over some of the crayon work, also in a loose sketchy way so that the colour is diluted but not blended in some areas, but not in others. Where the colour has blended, it creates a solid, shaded effect. The areas where the crayon has been left untouched, and where white paper shows through, depict the lit areas.

Ploughed Field

Michael Waw

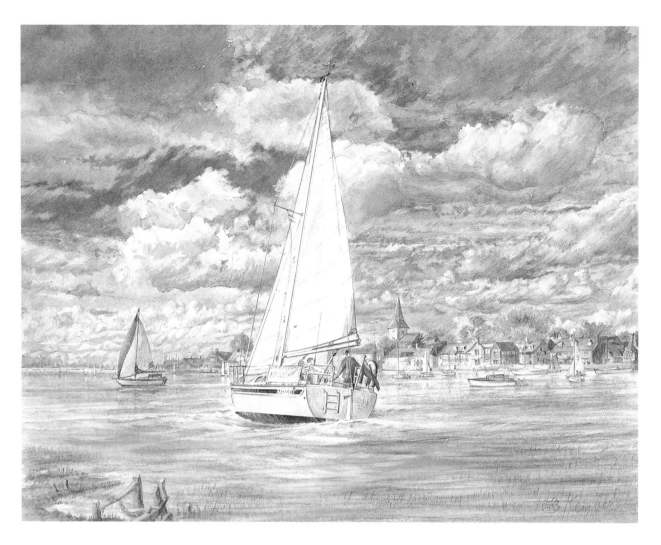

Bosham Harbour

KEVIN KEMBER

Water-soluble coloured pencil on Arches 300gsm (140lb)
watercolour paper

*This drawing has all the ingredients of a
successful sky. There is convincing movement and
recession in the cloud formations, which appear to
range from overhead to miles in the distance. The
blue passages are also well handled. The effects are
created by working pencil colour onto an already
dampened surface, not all at one time, but by
completing areas gradually according to the
dampness of the paper. Where dissolved colour is
wanted, and where colours need to blend into each
other, the area is shaded while the paper is still
quite wet. Where more textured colour is required,
that part is shaded when the paper is nearly dry.
The artist has not tried to disguise the fact that
water-soluble pencil is used; evidence of pencil
marks have been retained here and there, adding
life and verve to the composition.*

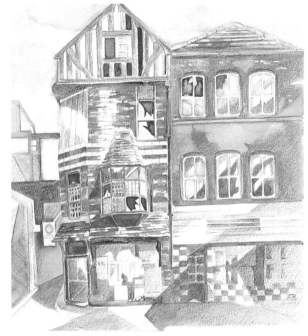

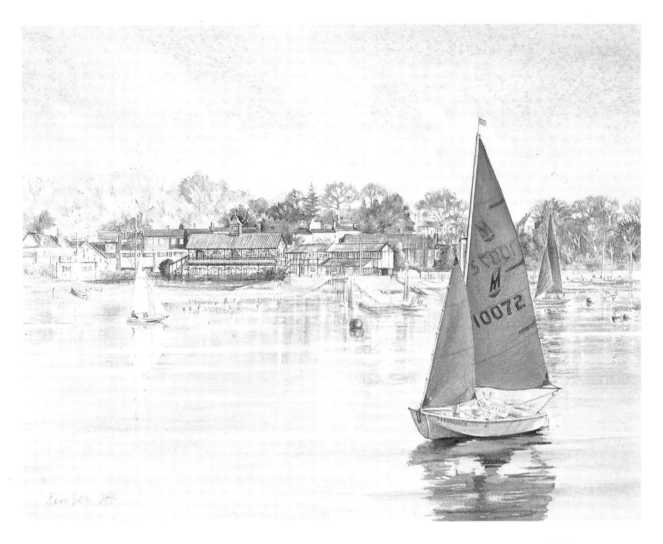

Street Corner

◁

SYLVIA WHITTALL

Water-soluble coloured pencil on Bockingford 300gsm (140lb)
watercolour paper

This street corner has been treated as a series of shapes, and the light and shadows form an important part of the composition. The drawing is made by shading in the blocks of colour with dry pencils onto dry paper. Then water is added to dilute the colours. More water has been added in some places than in others, so that in places the pencil grain has completely disappeared whereas in others it is still apparent. The colour handling is very subtle: although there are strong contrasts between light and dark, there is close colour harmony within the buildings and windows, and this is carried through to the distant buildings on the left and also into the sky.

Bembridge Harbour, Isle of Wight

KEVIN KEMBER

Water-soluble coloured pencils on Arches 300gsm (140lb)
watercolour paper

In this portrayal of calm water, horizontal pencil lines on the surface of the water help to create a feeling of peace and stillness. Reflections are broken up very little on calm water, and the almost mirror-like images here add to the impression of calmness. White Supracolor Fine pencil is used to create the mainly horizontal highlights on the water and the white in the reflections, producing a light, shimmering effect.

Contrast is provided by the foreground boat. These are produced by working dry pencil in horizontal strokes over a dry wash of colour. Soft trees and detailed buildings provide an interesting background for the boats. Graphite pencil was used for the shaded areas of the waterside buildings.

Afternoon Light, Connecticut

Water-soluble crayon on Bockingford watercolour paper

The eerie afternoon light is depicted by using only two colours: raw sienna and dark grey. Reasonable amounts of each colour pigment are applied onto a paper palette, and they are then picked up with a brush loaded with clean water and used in the traditional watercolour manner.

A dilute wash of sienna is applied to the sky, followed quickly by dilute dark grey. The paper is tilted in order to allow the colours to run down towards the horizon. While the paper is tilted, clean water is dropped into the wash, forming 'hanging' clouds. A no. 20 round Dalon brush is used for this work. As the sky dries, the paper is laid flat again and the shapes of the distant hills are introduced and allowed to merge slightly with the sky. The middle ground and foreground textures follow quickly, each consisting of mixtures of sienna and grey and the tone and colour strengthening towards the foreground. The washes are allowed to dry thoroughly before painting continues.

A rigger brush is used to paint in the fence and foreground features, and a spattering technique is employed in order to produce additional foreground textures which add interest. Finally the birds, flying off to seek a roosting place, are added with the rigger.

No drawing is used, apart from that produced with a rigger brush, and the whole painting is created with just the two colours mentioned and two very different brushes.

Australian Rainforest

BRENDA CHAPPELL

Coloured pencil on green mountboard

Greens – ranging from aquamarine to very yellow green – have been used to optimum effect in this composition. Some are achieved by overlaying one colour over another, others are direct from the pencil. Burnishing is apparent in the shafts of light filtering through the trees and also in creating highlights on the waterfall. Note how, on the surface of the stream, dark blue has been changed into light blue by burnishing white over it. Hints of ochre and brown on the branches and stems add interesting colour, which blends well with the surrounding greens and blues. There is even a subtle hint of purple here and there which provides a little extra depth!

FIGURES AND PORTRAITS

WHEN CHILDREN BEGIN to draw, it isn't long before they begin to produce pictures of their parents, although these may not be instantly recognisable. To the child, however, the image is clearly a parent and he or she will be surprised that the observer does not instantly see the image in the same way. The drawing may be just a face, but often the body will be included as well; portraiture and figure drawing are closely linked, of course, and children seem to realise this instinctively.

Although the human figure is probably the subject that all of us come into contact with more than any others. It is the most difficult for many people, possibly because, seeing ourselves every day in the mirror, we take the forms and shapes for granted. As with anything else, portraits and figures require practice and here again working in a sketchbook on location is an ideal way of coming to terms with them. Busy city areas are ideal places in which to find plenty of subjects.

It does not matter how crude your first attempts are; just remember that it is impossible to improve without practice.

just one colour, using only line. A good example of this can be seen in the work of caricaturists, who capture the 'essence' of a person with simple lines and the minimum amount of shading. Of the great artists, Picasso was a master of this style, and could describe the essence of a character very clearly with only two or three lines. Another approach that may help is to force yourself to work extremely quickly, because you have to concentrate on the most important and characteristic aspects of the subject.

Use your friends and relatives as subjects in the first instance; they are often around and can, with some friendly persuasion, be encouraged to sit still. Begin in this way, and when you feel confident you can tackle moving figures. Begin with pencil, but later on you can try other media. Even with a difficult subject, however, it is important not to lose sight of the fact that you should enjoy drawing as well as learning all the time. Being able to capture the likeness of someone can be very rewarding. Give it a try; you will not regret it.

OBSERVATION

The same approach is required when observing a face or figure as to any other subject. Establish the overall proportions of the head or figure, and then within this, decide on the relationship of one shape to another in terms of size and position. Start with some simple ideas and build on your experience in a gradual way. Perhaps attempt monochrome studies at first so that you can concentrate on modelling features without the added complication of trying to capture colours. You can move on to using a full range of colours when you feel ready to cope with shapes and shading. In the case of a portrait, it is possible to capture a likeness with

EXERCISE TO TRY

If a sitter is unavailable, you can always do a self-portrait. Arrange yourself in front of a mirror with the light falling at an angle across your face rather than coming from directly in front of or behind you; this will introduce modelling and cast. Don't think about drawing a likeness of yourself at this stage. Establish the overall shape and proportion of your head, then the main shapes of your features in the correct position in relation to each other, constantly moving from one to another and re-assessing what you have done. Avoid drawing outlines around features; instead try to build up the drawing with blocks of tone.

Fading Stars

Graphite and Pablo coloured pencils on heavy cartridge paper

An interesting technique worth trying is the method of transferring an image from a newspaper onto your chosen drawing surface. In this example, a newspaper photograph becomes the remains of an old cinema poster appearing as if it has been displayed on a brick wall.

To transfer the image, place it face down on the drawing paper and scribble across the reverse side with a 2H graphite pencil. Make sure that it does not move while you are doing this by securing it with masking tape. The pressure will transfer the newspaper ink onto your drawing surface.

In this composition, after the newspaper image had been transferred, the brick wall was shaded in using a selection of ochre, brown, sanguine, sepia and slate grey pencils.

111

READY TO DRIVE

W A T E R - S O L U B L E C R A Y O N

Water-soluble crayons are used in this project for speed of execution, as they can be used to shade in areas of colour quickly, which will give a sense of vitality and urgency to a moving subject as the golfer here. Quite solid blocks of colour are built up in the perceived shadow areas on the body. When the colour is dissolved with water, some of it is pulled across into the lit areas to create the light tones. With a moving subject, pick a particular stage in its movement, and observe it closely each time it returns to that position. It is more important to capture the position and balance of the moving figure than to include details, so aim to capture the overall shape and distribution of weight by observing the subject carefully.

C O L O U R S U S E D

Grey 7500.005 · Black 7500.009 · Ochre 7500.035 · Brown 7500.059 Sapphire Blue 7500.150 Malachite Green 7500.180 · Light Olive 7500.245 · Olive 7500.249

S U R F A C E

Bockingford 300gsm (140lb) watercolour paper

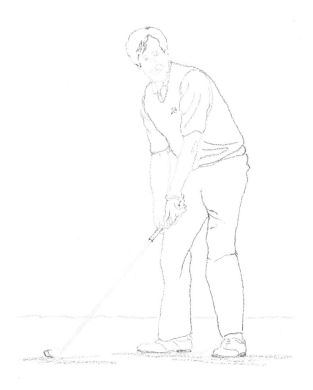

Step One The main shapes of the subject are outlined in the appropriate colour according to whether the area will eventually be light or dark.

When drawing a figure in action, study the balance of the body and the way the weight is distributed in order to capture the position.

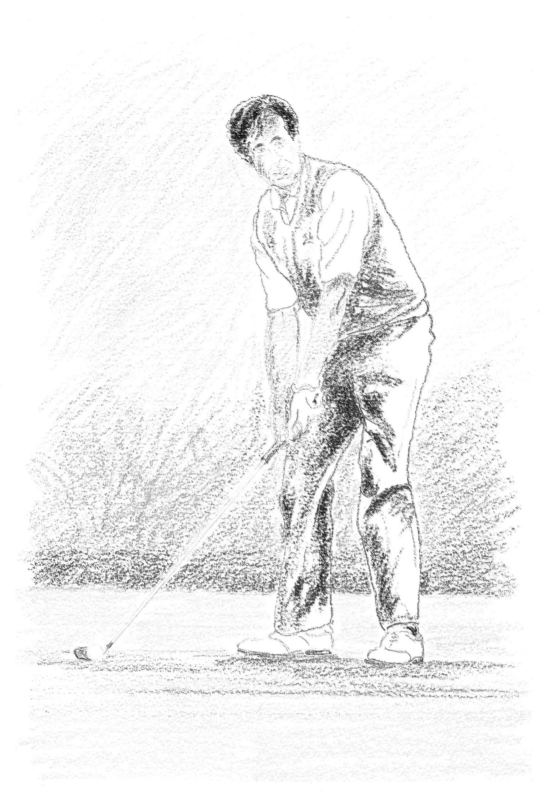

Step Two Colour is added to both figure and background. The background is lightly shaded in, with an indication of light and shadow being created through the use of light and dark tones of the same colour.

The shadow areas on the figure are shaded in more strongly, to produce a sense of the form of the figure. Note that application of colour is in broad strokes; the brush and water will continue to provide more detail.

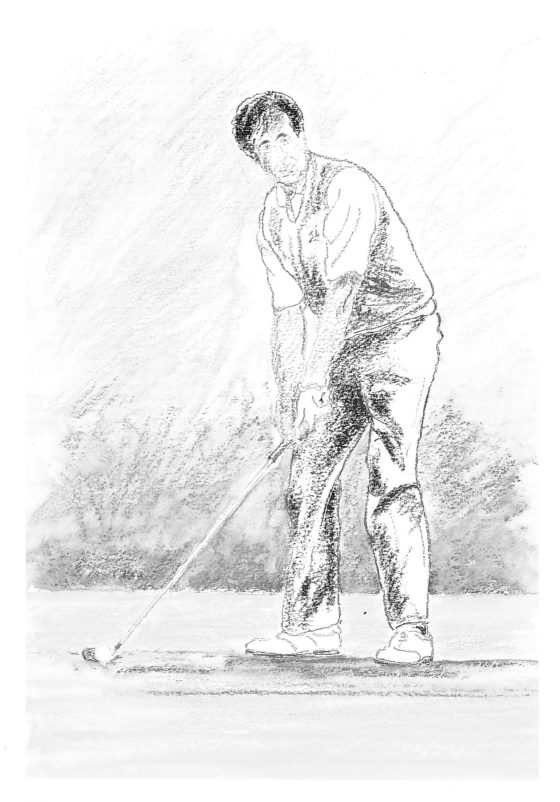

Step Three Water is applied in the background area with a no. 16 round Dalon brush. The soft crayon pigment previously applied begins to dissolve immediately and the whole process is carried out quickly, creating a wet-into-wet watercolour effect. A lightly worked, undefined background is the best way to emphasise the strength and boldness of the figure; an overworked area would be a distraction and would only succeed in lessening the impact.

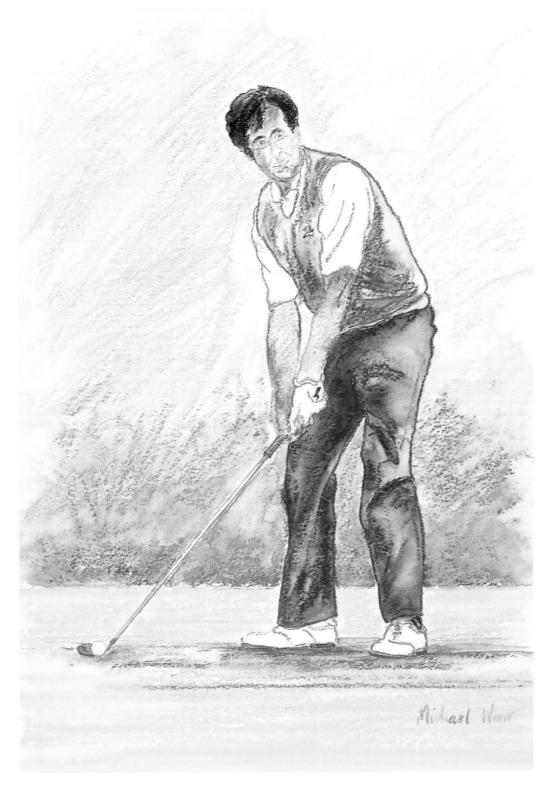

Step Four

As water is added to the figure with a no. 8 round sable brush, the colours come to life. Some colour is brushed across it to create the light-toned areas, previously untouched, but the modelling on it is still retained. The whole process is carried out quickly so that some of the colours can bleed one into the other, allowing the figure to remain alive. Pigment grain is retained here and there, adding an interesting textural quality to the clothing of the golfer portrayed.

Self-Portrait

ANDREW SUTTON

Pablo coloured pencil on 160gsm (70lb) Canson paper

The artist produced this self-portrait just after completing a failed drawing. He was in a bad mood, but enjoyed studying the colours that he saw reflected in the mirror. Skin colours are very subtle and are particularly responsive to colours in the surroundings; they can reflect a bewildering array of subtle hues, which should be moved into more substantial blocks of light and dark, and warm and cool colours to model the face, with touches of the predominant reflected colours. It came as a surprise to the artist while doing this drawing to see that there was a green shadow on his chin and neck.

Sunshine Girl

KEVIN KEMBER

Water-soluble graphite and coloured pencil on Canson Mi-Teintes pastel paper

A young girl's happy and infectious smile is caught in a carefully modelled drawing using light and dark pencils on a mid-toned paper. The graphite work is produced with Technalo water-soluble pencils and a Supracolor Soft water-soluble white pencil, which together produce a subtle, limited-palette effect. Light shading with the side of an HB pencil provides the underlying rendering required for the whole drawing. A B-grade pencil is used for the medium-dark lines and tones, and a 3B for the darkest lines and values – the darkest areas of the hair, the lips and underneath the eyelashes. Highlights are picked out with a white pencil. A dampened (but not soaked) no. 0 round sable brush is used to strengthen the dark lines around the eyes, lips and other details, including the darkest parts of the hair. The same brush slightly softens and blends the white highlights.

Three Fashion Drawings

LAVINIA BLANES

Coloured pencil and Neopastel on cartridge paper

In fashion drawings, the figure and clothes must be captured with the minimum of fuss. Here the artist has used pastel and coloured pencil in order to work quickly, describing the shape and movement of the clothes in simplified blocks and bands of colour, while describing the figures with the absolute minimum of lines – this ensures that the focus is on the clothing designs.

Colin

ANDREW SUTTON

Pablo coloured pencil on tinted Ingres pastel paper

A flamboyant art student provides a superb figure study; the colours to be explored are exceptional. The shadow areas in the hair are used to profile the face as he gazes downwards. The red and black streaks in the hair form a strong contrast that draws the eye to that area. The leather jacket, meanwhile, provides good reflective qualities. Purple jeans complete an ensemble of truly eccentric colours.

▷ Brazilian Dancer

ANDREW SUTTON

Pablo coloured pencil on Tiziano pastel paper

Andrew Sutton made this drawing as he observed the Brazilian dancer performing with a large percussion group on the Cours Mirabeau, Aix-en-Provence. The inclusion of the yellow-tinted rectangle behind the figure, through which the figure breaks out in various places, creates an atmosphere of concentrated energy. Areas of the arms and legs are left unfinished, which heightens the effect of movement.

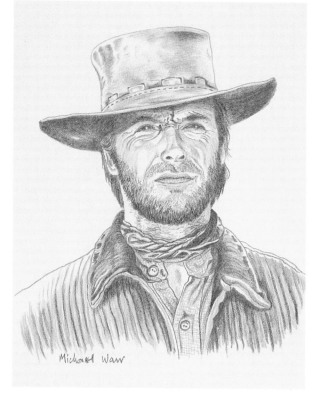

Marilyn

Pablo coloured pencil on cream 300gsm (140lb) Bockingford watercolour paper

This is an example of using one colour only in a drawing. It also seemed an interesting idea to use sanguine, a colour favoured by the Old Masters for drawing, and to apply it to a modern legend. The tinted paper provides the lightest tone, and the pressure applied while shading in the shadow areas is varied in order to create mid- and dark tones. A sharp point was maintained on the pencil through-out the drawing in order to reproduce the very fine lines.

Clint

Pablo coloured pencil on tinted paper

Sepia is the only colour used in this portrait of Clint Eastwood as he appears in the movie Two Mules for Sister Sarah. *The paper provides the lightest tone, light pencil shading the middle tones, and heavier use of colour produces dark tones on the under brim of the hat, echoed in the beard, neck-scarf and parts of the jacket. Good quality pigment is needed to produce rich, dark tones like these. Very little variation in tone is used to model the face, except where a strong shadow is cast by the brim of the hat.*

Fun with the Photocopier

Pablo coloured pencil on illustration board

This multiple image of Humphrey Bogart began with a black and white drawing, which is then photocopied at full size. This copy is reduced and the copier set on the basic print colours. The result *is an interesting multi-image print based on Andy Warhol's repeat paintings, which he produced extensively in the 1960s and which feature many well known personalities of the times.*

123

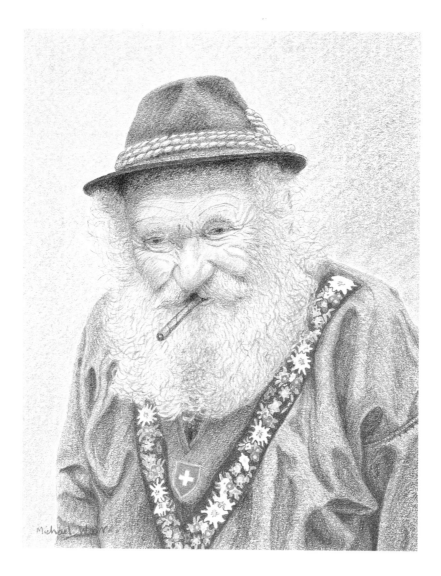

Man from Schwyz

Pablo coloured pencil on illustration board

This man lives in the old town of Schwyz, which gave its name to the whole of Switzerland. His local costume, complete with embroidered alpine flowers, and his wild beard presented a fascinating challenge; he became a must for a portrait, and he insisted on retaining his slim cigar. The high-key background is rendered with lightly hatched strokes to give some texture. Portrait backgrounds work better if they are kept simple so that they do not distract from or conflict with the subject. In this case notice how the warm background colours are similar to those in the face, while a contrast is provided by the strong blue in the jacket and colourful embroidered flowers. Another important feature is the way in which the folds in the jacket echo the age lines in the face. Portraits are not just a matter of achieving a likeness; interesting visual effects also need to be taken into consideration.

▷ ## Homeward Bound

ANDREW SUTTON

Pablo coloured pencil on white cartridge paper

Two figures observed separately in a living museum combine to create this delightful high-key drawing. The man's white shirt and the white blouse of the woman contrast well with their respective trousers and skirt, creating a striking tonal contrast that suggests strong sunlight, as do the warm, light yellow areas on the lower parts of the two figures. The colours in the clothing also appear in the ground area, and the blue of the woman's hat is echoed in the man's cap and belt, factors that unify the composition.

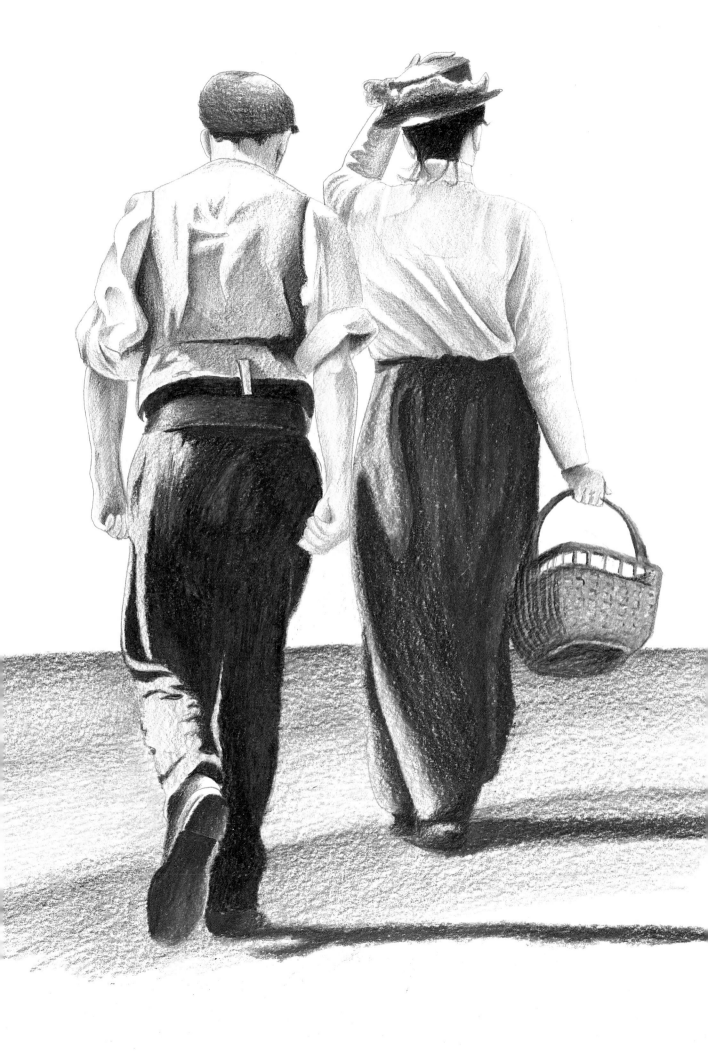

CONCLUSION

NOW THAT YOU have seen and tried out the many approaches and techniques that are possible with coloured pencils, you may want to choose one aspect, approach or type of subject matter to pursue further. If so, the most important point to bear in mind is to choose the medium that you feel most comfortable with.

Explore all the possibilities contained within your chosen medium to discover the full extent of what it is capable of, as this will help you to express your thoughts and feelings in a convincing and thorough manner. This, after all, is what we are hoping to achieve through our art works – but remember that the activity must remain enjoyable!

Books Enlighten (detail)

Water-soluble coloured pencils and crayons on Waterford 638gsm (300lb) paper.

ACKNOWLEDGEMENTS

The author and publisher would like to thank Caran d'Ache of Switzerland for their generous support of *Coloured Pencils For All*. The author has used Caran d'Ache materials throughout this book.

The author would also like to thank the following for their help and support: Richard Bailey (photography), Kate Yeates and Freya Dangerfield (editors at David & Charles) and Brenda Morrison (designer at David & Charles). Finally, many thanks to the guest artists who have allowed their work to be reproduced. They are: Lavinia Blanes, Brenda Chappell, Malcolm Davies, Kevin Kember, Steve Morewood, Muriel Smith, Jonathan Stephenson, Sylvia Whittal and Alec Wilcox.

Caran d'Ache can be contacted at the following addresses for further details of their products:

SWITZERLAND
Caran d'Ache SA
19 Chemin du Foron
CP 169
CH 1226 Thonex, Genève
Tel: 022 348 0204
Fax: 022 348 7521

USA
Caran d'Ache of Switzerland Inc
19 West 24th Street, 10th Floor
New York
NY 10010
Tel: 212 689 3590
Fax: 212 463 8536

BRITAIN
Jakar International Ltd
Hillside House
2–6 Friern Park
London N12 9BX
Tel: 0181 445 6377
Fax: 0181 445 2714

FRANCE
Ecridor, Caran d'Ache France
4 Rue Desbiolles
F/74240 Gaillard
Tel: 023 50 95 25 75
Fax: 023 50 37 57 41

INDEX